音樂劇 *Musical*

1937

戰火忘情

the Lost World's Love

編劇／作曲／作詞／小說
Screenwriter/Composer/Author/Nov

U0130644

中英雙語閱讀刊物
Chinese-English Bilingual Reading

本音樂劇影片榮獲美國 Accolade Global Film Competition 表彰獎（2016 年 3 月）

This musical film won an Award of Recognition: Film Feature of the Accolade Global Film Competition, USA (March 2016)

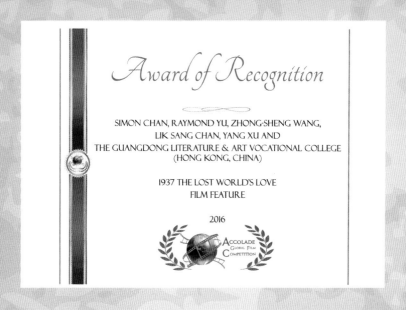

觀看《1937 戰火忘情》電影版，請瀏覽：

Visit website below for movie "1937 The Lost world's Love":
https://youtu.be/FuBBq-JvHG0

編劇 作曲 作詞：陳見宏
Screenwriter / Composer / Author : Simon Chan

自序

文學創作是不簡單的事。

我在政府工作時，需要寫不同的公文、一般書信、通告、會議記錄、報告、法律文件、招標書、合同，以至各式各樣的計劃書、可行性研究報告等。

離開政府後，自己做生意，但亦離不開處理文書事項，時常撰寫各類不同的計劃書、可行性研究報告等。優良的文書運作可以得著先機，增強生意成功機會。

兩年前，我有個奇想，既然我喜歡寫作，可否跳出商業框框，寫一些文學創作。文學創作是吃力不討好的工作。雖然，寫作可以擴大人的思想領域，可「天馬行空」，亦可「雲遊四海」，盡情發揮，但要有基礎，經過艱苦歷程，持之以恒，學習行文、語句等基本功課，多看書，才能從靈感中把要說的話和迷離景象情節描繪出來。

《1937 戰火忘情》是從寫小說開始，接著，我想何不創作一些有關故事的歌曲來點綴一下，二、三十首歌曲亦是這樣創作出來。編曲是音樂中的一門大學問，集不同樂器之大成和實際演奏經驗於一體，我找上我的音樂良師好友——旦哥，給他音樂原稿，他就給我編曲，這個配搭，真的太美妙了！

從中學時代，我已是「樂與怒」樂隊主音結他手，近年學習古典結他，除作曲外，音樂劇的結他演奏情節多是由我完成編曲。有一天，旦哥說他找到了演唱者，問我要歌詞，我曾經想尋求別人幫忙，但後來一想，反正我已開始寫小說，就來個「一不做，二不休」，自己寫歌詞，更得到家人的鼓勵，把小說內容重新組合，編寫成《1937 戰火忘情》的劇本，給這個音樂劇來個「全包宴」。

因為這個是中英文雙語創作，在寫作過程中是要考慮中英文在不同的文字結構下的表達方式，兩者內容大致相連，但不是譯本，所以，讀者看中文或英文版本時，不用「字對字」來看，從上文下理來看，就能領略兩種語言可以用不同的語句來表達箇中情意。

　　這次寫作是混合「詩詞歌賦」，配上社交對話等元素來充實內容，加強真實感覺。因為這是原創作品，不能墨守成規，套用《日知錄》卷十九云：「古人為賦，多假設之辭，序述往事，以為點綴，不必一一符同也。」

　　故事衍生自 1937 年上海四行倉庫保衛戰，女童軍送旗給守軍戰士，激勵國人抗日士氣，發展出浪漫、感動和引人入勝的情節。

<div align="right">

陳見宏
2016 年 2 月 12 日

</div>

Preface

Creative writing is a very difficult thing to do.

While working for the government during my earlier years, I had to cover many genres of writing styles from basic communications, formal letter writing, preparing reports and so on.

When I moved over to run my own business, writing played a big part in the success of this new career move with me playing a hands-on approach to all aspects of written communication that is necessary to underpin successful business functionalities.

It was only a couple of years ago when I started to toy with the idea of taking my writing to the challenging new level of creative writing. However, my move to this field wasn't a simple 'walk in the park'. Writing creatively sounds like a great way to have fun by letting your imagination run wild, but it is, in reality, more or less the direct opposite to this. Creative writing, I quickly learned, is a painstakingly difficult craft to develop as it requires a well-focused mind applying itself to a rigorous routine of disciplined work, a great understanding of syntax and language structure, and the ear for the rhetorical aspects of the language.

"1937 Lost World's Love" grew out of what became my first novel. Once I had the story narrated to a level I found acceptable, this then gave me the motivation to dress it up with some music and songs. After the first couple of songs, I quickly became aware of having a real live story with a beating heart in my hand. In no time at all, I had twenty to thirty songs written which

augmented and opened up an expansive new level and depth to the original story. My good friend and musical companion, Raymond Yu, then came to my aid to consolidate and refined things from that point on for me. Working on the musical scores I'd written, Raymond's unique abilities allowed the coals I gave him to be turned into sparkling diamonds.

My passion for music started in secondary school when I became a lead guitarist in a Rock & Roll band. In recent years, I studied classical guitar under formal tuition. This training well prepared me for when I turned my hand to this musical where, apart from the composing, I arranged most of the guitar pieces. When the time came to begin recording, Raymond found singers for the songs he had asked me to provide the lyrics for. I thought about finding others to write them for me, but in the end, I did it myself. My family members encouraged me to turn the novel into a play and that was how the musical came about.

The writing process for both the novel and musical involved me writing in Chinese and English. As such, this allowed me to integrate a level of fluidity in both the Chinese and English versions to suit the cultural dynamics of the targeted audiences, i.e. English speaking and Chinese speaking. Generally speaking, there is only a loose translation between the versions and they can't be compared in a direct "word for word" manner.

I used a mixture of poetry, verse, hymn and different social levels of dialogue in this work to create its unique language patterns. Jean Aitchison in her title "Linguistics" states "Every human language rings the changes on a finite number of patterns." For this purpose, I incorporated many Chinese idioms as metaphors to illustrate the complex phenomena of the novel.

The story is based on the history of the Battle of Shanghai in 1937. It begins with a girl-guide by the name of Wendy, who brings a national flag to the regiment of 800 soldiers defending the Sihang Warehouse.

<div align="right">Simon Chan, 12 Feb 2016</div>

《1937戰火忘情》 創作里程碑

- 2014 年 8 月——《1937 戰火忘情》音樂專輯於香港會議展覽中心香港高級視聽展發行。

- 2015 年 5 月——《1937 戰火忘情》於廣東文藝職業學院之郭蘭英劇院攝錄。

- 2015 年 8 月——《1937 戰火忘情》音樂劇於 24 家網路播放平臺播放，包括愛奇藝、騰訊視頻、優酷、搜狐等。

- 2015 年 8 月 14 日——《1937 戰火忘情》音樂專輯於中央人民廣播電臺《香港之聲》播放。

- 2015 年 9 月 3 日—— 《1937 戰火忘情》音樂劇於香港亞洲電視亞洲台和本港台播放。

- 2016 年 3 月—— 《1937 戰火忘情》音樂劇榮獲美國 Accolade Global Film Competition 表彰獎。

- 2016 年 6 月——《1937 戰火忘情》原創音樂劇電子書發行，中英文同版，於網上 Google Play、光波 24、Udn 讀書吧發售。

- 2016 年 7 月——《戰火忘情》中文小說於香港貿易發展局香港書展發售，亦於香港各大書局有售。

Production and Publication Milestone of "1937 The Lost World's Love"

➤ In August 2014, a CD album "1937 The Lost World's Love" was released at Hong Kong High-End Audio Visual Show, Hong Kong Convention and Exhibition Centre.

➤ In May 2015, the musical "1937 The Lost World's Love" was film-shot at Guo Lanying Theatre, Guangdong Literature & Art Vocational College.

➤ In August 2015, the musical "1937 The Lost World's Love" was played online on 24 platforms, including iQIYI, TencentVideo, Youku, Sohu, etc.

➤ On 14 August 2015, the CD album "1937 The Lost World's Love" was broadcasted online at "The Voice of Hong Kong" of China National Radio.

➤ On 3 September 2015, the musical "1937 The Lost World's Love" was broadcasted at channels Asia and ATV Home of Asia Television.

➤ In March 2016, the musical "1937 The Lost World's Love" won an Award of Recognition: Film Feature of Accolade Global Film Competition, U.S.A. (March 2016).

➤ In June 2016, an original musical ebook "1937 The Lost World's Love" in English and Chinese was published online at Google Play, 24Reader, reading.udn.

➤ In July 2016, a novel in Chinese "The Lost World's Love" was published and sold at Hong Kong Book Fair, HKTDC. It is available for sale at major bookstores in Hong Kong.

目錄 Index

四行倉庫保衛戰
簡介

　　一九三七年八月十三日，日本侵略軍進攻上海，中國軍隊奮起抵抗，展開了中國抗戰史上著名的八一三淞滬保衛戰。戰鬥歷時三月，殺傷日軍六萬餘人，後終因敵強我弱，我大場防線被突破，守軍國民革命軍第八十八師五二四團團長謝晉元當時任團附，奉命率部隊掩護主力轉移，於十月二十六日進駐上海四行倉庫，誓死固守，孤軍激戰四晝夜，斃敵二百餘，傷敵無數。

　　全國人民對這一震驚中外的抗戰英雄事蹟和愛國壯舉，無不崇佩感泣，稱他們為「八百戰士」，一九八五年九月三日，上海市文物保管委員會正式命名為「八百壯士四行倉庫抗日紀念地」，使這一驚天地、泣鬼神之英雄偉業常留人民心中，永誌紀念。

故事簡介

《1937 戰火忘情》為一大型歌舞音樂劇，製作故事背景取自 1937 年「淞滬會戰」，亦稱「上海戰役」。

故事始自四行倉庫八百戰士、女童軍（敏）送旗、國軍年青少尉（昇）成功保護敏送旗，振奮軍心。昇在行動中捨命護敏，贏取芳心，情緣暗結。國軍因彈藥殆盡，原地解散。昇肩負特別任務留敵區暗殺漢奸、日軍將領，行事中不幸牽涉敏在內，敏遭日軍憲兵拘捕，嚴刑拷問。雖最終獲救，逃往教堂，但為時已晚。敏臨終時在天主前與昇結為夫婦，並囑咐昇為她舉行一人葬禮。

SYNOPSIS

'1937 The Lost World's Love', is a grand musical based on the history of the Battle of Shanghai in 1937.

The story begins with a girl-guide by the name of Wendy, who brings a national flag to the regiment of 800 soldiers defending Sihang Warehouse. A National Revolutionary Army (NRA) second lieutenant by the name of Sheng, brings Wendy into focus when he encounters the enemy. The scene is set for a tragic love story that emerges in the midst of such a dramatic situation, where life and death are but a shadow apart. Because of the shortage of ammunition due to the ferocity and extreme callousness of the Japanese invasion, many of the soldiers simply have to abandon their weapons and supplies to go underground. Sheng's special task is to stay in the occupied area to assassinate traitors and Japanese army chiefs. Unfortunately Wendy is implicated in the assassination attempt of a Japanese colonel. She is arrested and taken away by the Kempeitai – the secret police. When Wendy is finally rescued from the jail, she flees to a church with Sheng and her father. But sadly, the excruciating torture she is forced to endure is too much even for one as brave as Wendy.

Sheng loves Wendy and when he realises her life is coming to an end, he proposes to marry her. At the end, the priest presides over the marriage ceremony and Sheng conducts a funeral ceremony alone before the Eyes of God, as Wendy's soul departs on its Heavenly journey.

旗情奇遇

　　1937年，日軍大舉入侵上海，發生鬼哭神嚎、舉世震驚的淞滬會戰，中、日投入近百萬大軍，未計算平民傷亡情況，死傷達三十多萬。

　　八百戰士奉命死守四行倉庫牽制日軍，掩護大軍撤退，保衛南京。

　　女童軍（敏）冒死送國旗給倉庫守軍，行動令人振奮。國軍少尉（昇）保護敏送旗，雙方在短短一刻生死邊緣的接觸，產生無盡愛意，私定終生。

　　國軍最終戰敗，11月12日上海淪陷，日軍以勝利者姿態進入國際租界，顯示日軍冷酷、無情，上海市民傷感、悲憤、無奈。

　　昇和群眾悲壯歌舞，顯示中國人不會因一時的失敗而沮喪。

Act One
The Flag

It was the year 1937 when Japanese troops invaded Shanghai, culminating in the Battle of Shanghai, a battle that even frightened the ghosts and sent shock waves across the world. Nearly one million soldiers were involved in the battle, of which three hundred thousand never returned or were severely wounded.

A regiment of 800 soldiers was ordered to defend the Sihang Warehouse to cover the massive retreat of troops sent to protect Nanking.

Fearlessly, a girl-guide, Wendy, brings a national flag to the troops in the Sihang Warehouse. Her bravery impresses the soldiers and greatly encourages them. NRA second lieutenant, Sheng, is ordered to protect Wendy as she carries the flag, during this tumultuous time, when life and death are but a shadow apart which results in them falling in love with each other.

Alas, the NRA was defeated and Shanghai was overrun by the Japanese invaders. On the 12th of November, 1937, Japanese troops celebrated their victory in taking possession of the city with a great march. They paraded their callous and merciless behaviour to all that lined the route as an act of defiant suppression and hostility.

Sheng begins to sing, 'Hero March', as others join in dancing and singing as a defiant gesture to show that the Chinese spirit will never be broken or defeated.

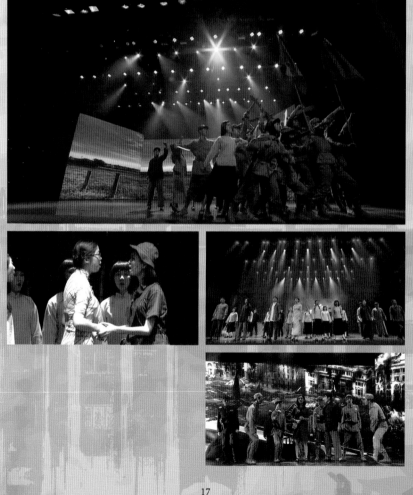

第一幕 Act One

第一場 Scene One

➢ 背景：上海街道
Background: Streets of Shanghai

➢ 唱／奏：前奏曲（5'18"）
Song: Overture (5'18")

旁述 Narrative	開場示威遊行： 難民帶著惶恐的表情望著天空，難民愈來愈多，跌跌撞撞，有的相互挽扶，聚在一起。一群遊行學生出來，舉著標語，喊著口號。受到學生的鼓舞，難民的表情由惶恐變得充滿鬥志（悲憤），他們加入學生的遊行陣列。	Refugees flee from war and famine. Students go on strike to thwart the Japanese invasion.
歌詞 Lyrics	戰禍天災 良田荒廢 饑民逃荒　饑寒交迫 中國人站起來戰鬥	Cruel war unnatural disaster. Farmland abandoned, Hungry people flee from famine. Chinese stand and fight!
	戰火紛飛　大破壞 災難來 殘酷殺戮 燒國土 毀家園	The fire of war causing great damage. Disaster emerges. Cruel massacre. Burning land. Destroying dwellings.

	中國人起來	Chinese stand up!
	保衞家園	Protect our country!
	衝鋒殺敵	Revolt to kill enemy!
	戰鬥到底	Fighting to the end!
	漫天戰火奪人命	Flames of the war fill up the sky, people killed.
	遍地災民哭震天	Refugees crying all over the place.
橫幅 Banner	還我山河	Return our Country!
	抗戰到底	Fight to the end!
歌詞 Lyrics	誓雪國恥	Take revenge of national humiliation.
	誓化悲憤為力量	Converting grief and indignation into energy.
	勇灑熱血報國仇	Springing off hot blood to assuage the national enmity.
	漫天戰火奪人命	Flames of the war fill up the sky, people killed.
	遍地災民哭震天	Refugees crying all over the place.
口號 Slogan	我們不做亡國奴！	We can't be subjugated or humiliated!
	我們要戰鬥！	We must fight!
	戰鬥！	Fight to the end!
	打倒日本帝國主義！	Overthrowing Japanese Imperialism!
	抗戰到底！	Fighting to the end!
歌詞 Lyrics	全民皆兵	Bringing the entire nation to arms!
	英勇殺敵	Bravery to kill enemy!
	抗戰到底	Fighting to the end!
	戰禍天災	Cruel war unnatural disaster.
	良田荒廢	Farmland abandoned,
	饑民逃荒　饑寒交迫	Hungry people flee from famine.
	中國人站起來戰鬥	Chinese stand up and fight!

第二場 Scene Two

➢ 背景：震旦女子文理學院
　Background: Zhen Dan Women's Art & Science College

➢ 唱／奏：勇者呼喚（1'25"）
　Song: School Song (1'25")

口號 Slogan	團結就是力量！	Solidarity is energy!
歌詞 Lyrics	神州大地	Homeland's vastness.
	蒼生萬物	Coddles our growth.
	孕育中國人	Gives us food and peace.
	多元文化　融洽相處	People of multi cultures are living happily
	美好的國家	in the beautiful country.
	震旦學院	Zhen Dan our school
	教育我們　知識和仁愛	Teaching all kinds of knowledge and charity.
	老師學生	Teachers and students
	相親相愛	Loving each other
	恰似一家人	Live like family.
旁白 Narrative	同學們，出事了！	Girls, bad things have happened.
	日本兵已經打到閘北區	Japanese troops have invaded Chapei.
	我軍八百壯士在四行倉庫奮力狙擊。	800 of our national army are fighting hard at the Sihang Warehouse.
	商會會長叫我們派人去送國旗，以鼓舞我軍士氣！	Head of the Chamber of Commerce wants us to bring a national flag to the soldiers to boost their morale.

歌詞 Lyrics	倭寇入侵	Suddenly,
	上海遇襲	Shanghai is plundered!
	國軍奮戰鬥	National army fights!
	四行倉庫	Sihang Warehouse.
	八百戰士	Eight hundred soldiers.
	誓作戰到底	Fighting against the wee Japanese troops.
	戰士需旗　告知世界	They need a flag to show the world
	永不言投降	Chinese won't surrender!
	誰能送旗　給戰士們	Who will send a flag to the soldiers?
	我們支持她	We are supporting her!
對白 Dialogue	你們誰去送國旗？	Who will bring the flag to the soldiers?
	我去！	I'll go!
	我是中國人， 不怕死， 我願意去送國旗！	Chinese I am! I am not afraid of death! I'll bring the flag to the soldiers!

第三場 Scene Three

> ## 背景：四行倉庫部隊作戰室
> ## Background: Command Centre

> ## 唱／奏：行動命令（1'12"）
> ## Song: The General's Order (1'12")

歌詞 Lyrics	報告長官（敬禮），參謀長電報	(Salute) Here is the Commander's cable!
	幹啥來電 趕快給我念	What's it about? Read it to me!
	上海人民對四行倉庫 八百戰士殺敵很敬佩 他們送旗給英勇戰士 派人保護女童軍敏前來 送旗，在匯中飯店等侯 命令	Shanghai people are impressed that we fight hard to kill the wee Japanese. They want to send a flag to our troops. Send a man to protect the girl-guide Wendy who waits at the Palace Hotel. This is an order!
	找少尉昇立即來見我 指令他去保護女童軍	Find me second lieutenant Sheng now. I want him to protect the girl-guide.
	團座長官，昇少尉報到 等待團座給行動指令	Sir, second lieutenant Sheng reporting. I am waiting for your orders.
	去匯中飯店 保護女童軍敏送國旗過來 讓世界知道中國人拼死作戰到底，抗侵略	Go to the Palace Hotel. Safe-guard the girl-guide – Wendy who'll bring the flag here. It's showing the world that we're brave and fight hard against the invasion.

作為軍人	As a solider,
昇向團座保證誓死去保	I swear to you I must get it done in order,
衛女童軍敏和國旗安全	Bringing the girl and the flag to our
地到達	troops safely.
不會猶豫	No doubt.
這是光榮神聖的任務	This is a sacred mission.
我不懼困難勇往向前	I'm not afraid of going ahead.
讓世界知道中國人拼死	To demonstrate to the world that we're
作戰到底，抗侵略	brave and fight hard against the invasion.
中國人拼死作戰到底，	We're brave and fight hard against the
抗侵略	invasion!

第四場 Scene Four

> 背景：震旦女子文理學院
> Background: Zhen Dan Women's Art & Science College

> 唱／奏：勇者呼喚（35"）
> Song: School Song (35")

歌詞 Lyrics	大敵當前	Having big enemy,
	一起戰鬥　驅賊離國土	We must fight till they leave our land.
	通告世界　誓死奮戰	We'll show the world how brave we are,
	永不會氣餒	never to be defeated.
	Wendy 英勇　送旗戰士	We are proud of Wendy's heroics and give
	給她大力量	her all our encouragement.
	她和我們　一起抗戰	She won't be alone as we bide with her.
	光榮中國人	Glory be to the Chinese!
	光榮中國人	Glory be to the Chinese!

第五場 Scene Five

> 背景：四行倉庫大閘近河邊
> Background: Main Gate at the Sihang Warehouse

> 奏：危機四伏（1'26"）
> Music: The General's Order (1'26")

對白 Dialogue		
	昇，你去哪裡？	Sheng, where are you going?
	去租界接人。	I'm off to the Settlement to pick someone up.
	接人？ 你不能穿軍服去。	To pick someone up? You can't wear your army uniform.
	放心， 我早有準備。	Don't worry. I've prepared for it.
	哇，茱利， 你果然是神槍手啊！	Wow Julie. You're a sharpshooter.
	給， 這是密林手槍。	Take it. It's a Magnum pistol.
	謝謝你。	Thanks a lot.
	你不要在橋面上走， 不要給租界的人發現你， 他們會捉你的。	Don't go on the bridge. Don't let the Japs or police see you. You'll be under arrest or dead and quickly so.
	明白。	Got it.

不要回頭，這會暴露我位置	Don't look back, otherwise I'm exposed.
回來時，在橋頭給我信號	Signal me when you're at the foot of the bridge.
我去掩護你回來	I'll cover you when you get back.
注意安全	Be safe.
好。	Good.

第六場 Scene Six

> 背景：上海公共租界匯中飯店
> Background: Palace Hotel

> 奏：匯中飯店尋人（過門音樂）（32"）
> Music: Where Are You? (32")

> 唱：他從天邊來（短）（1'）
> Song: Shuffling In The Sky (Short) (1')

對白 **Dialogue**	小子啊，找人嗎？	Kid Are you looking for someone?
	對呀，你是……	Yes, you.
	我是國軍。	I am a second lieutenant from the NRA.
	國軍，你是否來找我姐？	NRA Are you looking for my sister?
	姐？	Sister.
	誰是你姐？	Who is your sister?
	女童軍嗎？	You mean the girl-guide.
	對呀！	Yes.
	姐，	Sister.
	有人來。	Someone's come for you.
歌詞 **Lyrics**	你是否從天邊來	Do you come from the sky?
	可有迷失半途中	And you got lost in time.
	哪個時空不選擇	Why do you choose this troubled space
	偏偏跑來亂世間	Coming to give me a bitter taste?

	這位少女很面善	Have I met her somewhere else?
	不知在何方遇見	Bonny faced for me to detail.
	她的美貌令我醉	Sweet voices echo in my ear.
	甜蜜聲音永難忘	Never vanish this I fear.
對白 Dialogue	你，就是敏？	Are you Wendy?
	我就是，你是。	Yes And you are.
	我是國軍少尉， 我叫昇， 國旗呢？	Second lieutenant Sheng. Call me Sheng. So… Where is the flag?
	在背包裡。	In my backpack.
	好，那咱們走。	Then let's be off.
	等等，聰。	Wait John.
	姐，你，你快去， 我在這兒等你。	Sister, you must go quickly. I'll wait for you here.
	不要亂跑， 我很快就回來。	Stay unseen. I'll be back soon.
	放心吧。 我一定會安全護送你姐 回來。	Don't worry. I promise I'll send your sister back safely.
	好， 小心點。	I trust you. Be careful.

第七場 Scene Seven

> 背景：四行倉庫大閘近河邊
> Background: Main Gate at the Sihang Warehouse

> 唱／奏：佛朗明哥火鳥（2'35"）
> Music: Flamenco Firebird (2'35")

對白 Dialogue		
	低點， 再低點，	Lower your body As low as you can go.
	跟緊我。	Follow me.
	死了嗎？	Is he dead?
	死了。	Dead already, as dead as a door nail.
	你沒事吧？	Are you okay?

第八場 Scene Eight

➤ **背景：四行倉庫**
 Background: Sihang Warehouse

➤ **唱：勇妹**（1'02"）
 Song: Brave Girl (1'02")

➤ **奏：空襲**
 Music: Air Attack

對白 Dialogue		
	報告，團長，護送女童軍敏安全到達。	I'm here to report. Wendy has arrived safely.
	團長，女童軍敏送旗給四行倉庫八百守軍。	Sir, I am glad to present the flag to the regiment of 800 soldiers.
	昇，幹得好！	Sheng, you did a good job.
	團長！	Sir.
	好，我們把旗升起來，讓世界知道，中國人永不投降！	Okay, let's fly our glorious flag. To tell the whole world that Chinese people never surrender.
	永不投降！	Never surrender.
	立正，敬禮！	Stand still Salute.
	敬禮！	Salute.

歌詞 Lyrics	勇妹	Brave girl!
	從天來的勇妹 奇異來送旗 哼，侵略者必敗 狂吼聲震天	Here comes the brave girl Brought the flag in wonder! The invasion is plunder! We roar like thunder!
	勝利屬我們 邪惡必自斃 衝鋒槍林彈雨下 你真是勇妹	We have the right to justice. Evil minds end in crashes. We don't fear gunfire. You are our brave girl.
	國旗加強士氣 沒反悔、無憾 龐大力量殺敵 國旗飛揚昇	Our flag, the spirit of bravery. Your spirit is uncompromised Power to overcome enemies. Strong winds fuel our flag.
	國旗令加強信念 你真是勇妹 奇蹟有如天助 勇敢中國人	Our flag makes us stand our ground. You are indeed our brave girl. Miracle as if assisted by god. We are brave Chinese.
對白 Dialogue	昇，快送敏返回去，這裡很危險！	Sheng, it's dangerous here, bring Wendy back to the Settlement.
	遵命，團長！	Understood, Commander.
	小心一點！	Be careful!
	好！	I will.

第九場 Scene Nine

➤ 背景：公共租界蘇州河畔
Background: Suchow Creek

➤ 唱／奏：生死戀（3'26"）
Song: Life & Death Love (3'26")

對白 Dialogue	謝謝你保護我。	Thank you for protecting me.
	這是我應該做的， 你的勇敢令我敬佩。	It is my duty. I admire your courage.
	你先說。	You say first.
	不知道甚麼時候我們才 能再次相見？	I don't know when we will see one another again.
	我相信會有這麼一天 的。	I believe the day will happen.
	我也相信， 我也相信會有這麼一天 的。	I believe it too. I also believe the day will happen.
	為甚麼？	Why?
	也許， 這就是緣份吧！	Perhaps, It is destiny that will play its hand.
歌詞 Lyrics	今天我們在此偶遇 是前生註定 您我之間情愛無限 不知何時了	In this era of fire, we meet. Destined by heaven, Love emerges, embraces us. Something really occurs.

人生在世	Life on earth.
兒女私情	Passion of love.
是沒完沒了	No ending ever in sight.
國難當前	Invaders here.
家破人亡	Country breaking.
愛情算甚麼	Crumbles breaking hearts.
今天見面	Hello sunrise.
明天分手	Goodbye moonlight.
是否太殘酷	Why aren't you feeling sad?
千絲的愛	Love's splendor.
萬縷的情	Passion's fire.
如何去解決	Enduring indifference.
放下感情	Set love aside.
重新裝備	Reinvent myself.
願為國犧牲	A soldier boy to protect our land.
衝鋒殺敵	Kill invaders!
軍人天職	Soldier's on!
置生死度外	Without fear nor worry to dull the pain.
今天相愛	My love to you
終生無悔	Will not change of that you can be assured.
不管在何方	Anywhere you go,
您要永記給您的愛	No matter how far and wide,
不能去忘懷	I'll be there for you.
今生我們不能聚	If we can't be together,
來世也要去繼續	In the next life we'll carry on.
今天的愛　永記於心	The love we have will be remembered.
不管在何方	No matter where you are,
您我的情　今生不盡	If our love should be prevented,
來世也要續	It will be extended in the next life.

這是我的護身符，
我把它送給你。

This is my amulet.
Now it's yours.

護身符？

Your amulet.

這是一隻孔雀，
你就像孔雀一樣美麗。

It is a peacock.
You are as pretty as a peacock.

我要走了。

I have to leave now.

好。

Take care.

➤ **背景：四行倉庫**
Background: Sihang Warehouse

➤ **人物：團長、守四行倉庫官兵、少尉昇、茱利**
Characters: Commander, Soldiers, Sheng, Julie

➤ **內容：四行倉庫守軍解散**
Content: Dismissal of Troops

對白 Dialogue		
	兄弟們， 接到上級命令， 四行倉庫阻擊戰任務已經完成， 參謀長令我部連夜撤退。	Brothers! The order has come. The battle of thwarting the wee Japanese has been completed. The commander has ordered us to retreat.
	是。	Yes sir.
	昇、茱利， 你們兩個留下， 我有話要說。	Sheng, Julie. Stay behind. I have a few words for you.
	你們倆留在敵戰區收集情報，執行暗殺任務。 絕不能讓敵人肆無忌憚。	Both of you have to stay in the occupied area to collect intelligence and carry out the assassination. We can't allow them to roam scot free.
	是。	Yes sir.
	注意安全。 保重。	Be vigilant all times. Take care.

第十場 Scene Ten

➢ 背景：1937 年 11 月 12 日上海淪陷，閘北區
Background: Chapei district.
Shanghai was overrun on 12 November 1937

➢ 唱／奏：剌刀進行曲（3'05"）
Song: Bayonet March (3'05")

哼聲 Croon	天涯……	O' Heaven …
對白 Dialogue	混蛋	Bastard!
歌詞 Lyrics	小醜八怪喧嘩嘩吃壽麵	Chinese Doodles want to eat long noodles.
	肥臉童子坐在長城大叫	Humpty Dumpty sitting on the long Great Wall.
	他們大聲叫要吃長壽麵	Crying out to all the world. Give them the long long noodles.
	腸轆轆小怪怪模怪樣叫 我們沒有同情心 沒有餘糧養閒人 兩個傻瓜要吃麵 不要命來剌刀尖上拿	Hungry Doodle's dumpy-clumsy dumb. They're dumpy-clumsy dumbos. Doodle Dumpty makes me laugh. If you want to eat those noodles, Come and take it from my bayonet.
	小醜八怪呱呱叫 叫到長城邊 肥臉童子跑回家 跑到地獄去	Chinese Doodles, the dumpy dumbo Dumping everywhere on the Wall. Humpty Dumpty's going home. There will be hell to pay if he falls.

	轆轆小怪傻傻肥子	Hungry Doodles, silly Dumpty!
	長城滾下來	Rolling down the Wall,
	小怪肥子大吵大鬧	Doodle Dumpty crying out to the world.
	沒有長壽麵	Yes, they have no noodles.
	我們沒有同情心	They're dumpy-clumsy dumbos.
	沒有餘糧養閒人	Doodle Dumpty makes me laugh.
	兩個傻瓜要吃麵	If you want to eat noodles,
	不要命來刺刀尖上拿	Come and take it from my bayonet.
	小醜八怪呱呱叫	Chinese Doodles are dumpy dumbos.
	叫到長城邊	Dumping everywhere on the Wall.
	肥臉童子跑回家	Humpty Dumpty's going home.
	跑到地獄去	There will be hell to pay if he falls.
	轆轆小怪傻傻肥子	Hungry Doodles, silly Dumpty.
	長城滾下來	Rolling down the Wall,
	小怪肥子大吵大鬧	Doodle Dumpty crying out to the world.
	沒有長壽麵	Yes, they have no noodles.
	小怪肥子叫	Doodle Dumpty dah.
	小怪肥子跳	Doodle Dumpty dumb.
	他們呱呱叫	Doodle Dumpty dumb.
對白 Dialogue	人……捉到沒有？	Hey Have you got anyone?
	混蛋！	Bastard!

第十一場 Scene Eleven

> 背景：淪陷上海閘北區
> Background: Chapei district, the occupied area

> 唱／奏：英雄進行曲（2'45"）
> Song: Hero March (2'45")

旁白 Narrative	中國人不做亡國奴！	The Chinese people won't be subjugated.
歌詞 Lyrics	我們前進前進去戰場 不會害怕	We are marching marching to the war, Without fear.
	我們前進前進到大海 乘風破浪	We are marching marching to the sea, Riding on the waves.
	我們前進前進去天空 騰雲風送	We are marching marching in the sky, Being blown by the wind.
	我們充滿大力量前進	We are marching marching with all our strength,
	保衛家園	Fighting for our land.
	每一個人　不分老幼 一齊來前進	Everybody, all the people coming to the march.
	前進給予　戰鬥力量 決心戰到底	Marching gives us the power to fight, Fighting to the end.
	你也前進　他也前進 都是前進隊	He is marching, she is marching. We're the marching force.
	前進給予　戰鬥力量 咱們是英雄	Marching gives us power to fight. We are all heroes.

小狗跑前貓也來	Dogs are running, cats are running too!
向前進微笑	Cheering along to the march,
所有人都跑出來	Everybody's coming out!
向前進鼓掌	Clapping hands for the brave,
我們把敵人踢走	We are kicking out our enemies!
踢到大海去	Kicking them far out to sea,
前進戰鬥護大地	We are fighting for our land!
咱們是英雄	Heroes all are we!
有天我們前進祝勝利	One day we will march to celebrate
打了勝仗	The war which we finally win.
痛把敵人驅逐出國土	We've kicked the enemy out of our land.
齊來慶賀	We are cheering!
重重地懲罰戰爭罪犯	All our enemy are facing trial!
判處死刑	The death sentence their recoil!
我們前進前進去彩虹	We're marching marching to a rainbow!
保衛家園	We are heroes!
左右左右，左左右	Left Right Left Right Left Left Right
左右左右，左	Left Right Left Right Left
右左右左，右右左	Right Left Right Left Right Right Left
右左右左，右	Right Left Right Left Right
一二三四，	One Two Three Four
四三二一	Four Three Two One
一二三四，一	One Two Three Four One
一二三四，	One Two Three Four
四三二一	Four Three Two One
一二三四，跑	One Two Three Four Run
小狗跑前貓也來	Dogs are running, cats are running too!
跑向前進隊	Running to the march,
所有人都跑出來	Everybody is running too!
跑向前進隊	Running to the march,
他們向前進微笑	They are cheering and marching!
給予戰鬥力	To give us added power,
我們決心戰到底	We are fighting to the end!
咱們是英雄	We are all heroes!

第二幕
生死之間

　　在淞滬會戰後，昇與戰友茉利奉命留在上海執行鋤奸任務，昇以音樂助理查禮的身份混入百樂門大舞廳，協助樂隊領班工作，亦積極找尋敏。

　　有一天，昇在租界人海中尋人，看見街頭演藝者演奏吉他音樂《孔雀舞》，旁有一小女孩穿著孔雀戲服跳舞。昇深深被他們的表演感動，感懷身世，獨唱《軍人心聲》。

　　在沒落世界、紙醉金迷的世態下，上海租界百樂門夜總會慶祝1938新一年來臨，於大除夕夜舉辦化妝舞會。昇要在歌舞大廳執行暗殺日軍將領任務。

　　當晚夜總會舉行化妝舞會，眾人互不見真面目，沉醉於虛偽乏味的歡樂中，現場奏著《月影舞曲》，昇在柔和但心情起伏不定的音樂中跳舞，感覺到身邊的少女是敏。

　　敏跟隨父親來夜總會，參加盛會，敏父是上海商會會長，他看是漢奸，實際為地下戰士，保護愛國人士。

　　昇的戰友茉利亦隱藏身份在百樂門做歌星，她獻唱《花世界、夜上海》娛賓。

　　樂隊奏出《月影舞曲》時，邀請敏和昇合唱，歌詞內容深刻表達他們再遇的感受，雙方在這刻心情不能自禁，離開大廳在露臺上互訴離別牽掛之苦，唱出《深思愛侶》。

　　昇當晚要暗殺日本將領犬養大佐，在1938年來臨前一刻倒數至零時，現場施放花紙和噴出煙霧，舞蹈藝員正在表演激昂歌舞《上海波爾卡舞》，昇出其不意，槍擊犬養，場面混亂，茉利熄燈掩護昇和敏逃離百樂門。

昇和敏逃到蘇州河畔，是他們第一次定情的地方，雙方泣訴離別之苦，合唱歌曲《晨露》。昇不知敏父的真正身份，對他為虎作倀，表示憤慨，雙方為此爭吵，最終冰釋，和好如初。昇離開後，敏又思念昇，在河畔獨唱《他從天邊來》，表示無限牽掛昇的情懷。

Act Two

Life and Death

Right after the Battle of Shanghai, Sheng and his comrade-in-arms Julie are ordered to weed out traitors among the Chinese people in Shanghai. He covers his identity, calling himself Charlie and pretending to work as a music assistant to the bandleader of The Paramount Ballroom. All the while he is longing for Wendy so badly.

One day, as he is searching for Wendy, himself immersed in a sea of people, his attention is suddenly caught by a street performer playing a song on guitar 'The Peacock Dance' who has a small girl by his side in a peacock costume dancing to the music. This performance deeply affects him with great emotion making him so sad he starts singing the song 'Soldier Blues', which completely overwhelms him.

In this realm of the lost world dazzling with paper (status) and gold (wealth), the Paramount Ballroom is holding a New Year's Eve masquerade ball for the countdown to the New Year of 1938. Sheng's mission is to assassinate a Japanese colonel whose party is also celebrating there that evening.

Under the guise of anonymity with guests dressed in colorful costumes and masks, the focus is on the movement and chatter as the 'Moonlight Shadow Waltz' plays. In the midst of all of this excitement, Sheng, also disguised, feels intuitively that the girl passing by him is Wendy.

Wendy's father, Mr Yang, who is President of Shanghai Chamber of Commerce, brought her along to the ball at the Paramount for support. People in his position are considered to be traitors by many of his people as they are forced to interact with the Japanese to carry out their business. In fact, however, her father is deeply patriotic and is a key mover behind the Chinese Resistance.

Sheng's comrade Julie who is also disguised, works as a singer in the Paramount. She sings 'Floral World, Shanghai Night' to entertain the guests.

As the band plays 'Moonlight Shadow Waltz', Wendy and Sheng in turn, become enmeshed with the music that echoes their sad feelings over their forced separation. Overcome with emotion, they both beat a hasty retreat to the balcony to sing 'Love in Deep Memory'.

Ever vigilant of his task to assassinate the Japanese Colonel, Inukai, and, amidst the colour, perfumes and odours, and gay abandonment of movement taking place as the count down to zero begins to usher in New Year 1938, while the band plays 'Shanghai Polka', Sheng's resilience and deadly accurate marksmanship makes its fated mark on the temple of Inukai. The lights are extinguished by Julie allowing Sheng and Wendy the cover to flee the Paramount as the Kempeitai and pandemonium set in.

Sheng takes Wendy to Suchow Creek, the place where they first met; and they weep for their love of each other, full of sad words expressing their grief of separation in the song 'Morning Dew'. Sheng, unaware of the real identity of Wendy's father, passes an adverse judgment and even grumbles about her father working for the Japanese. All the same, lovers' quarrels do come and go and finally are set aside as love melts all away!

When Sheng leaves, Wendy misses him so achingly. She sings 'Shuffling In The Sky' in a bid to recall and reminiscence all that he means to her.

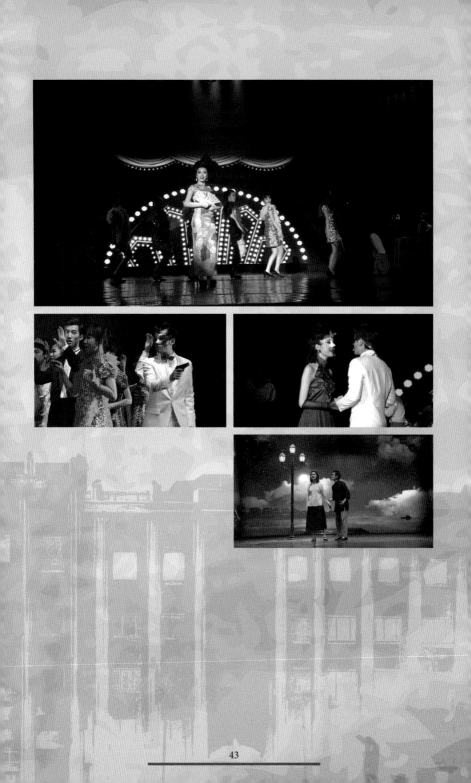

第二幕 Act Two

第一場 Scene One

> **背景：上海法租界街頭**
> Background: Streets of International Settlement

> **背景音樂：孔雀舞（配以人扮小貓小狗和孔雀共舞）（2'21"）**
> Music: Peacock Dance (2'21")

> **唱／奏：軍人心聲（2'29"）**
> Song: Soldier Blues (2'29")

對白 Dialogue		
	你去跳舞吧！	Go dancing!
	唉，停一下。	Sigh Wait.
	給他。	Give him money.
	我們走。	Let's go.
	等等。	Wait.
歌詞 Lyrics	戰火來　家沒了	War flames flare No more homes
	多人無家可歸	Homeless people everywhere.
	我也是　一個人	I too am alone.
	不知能幹甚麼	I don't know what to do.
	立志去當軍人	I've decided to become a soldier again
	保衛國家	To protect our country.
	不怕把命獻出來	I'm not worried for my personal safety.
	大夥兒　站起來	All people stand
	一起抵抗侵略	And fight against the invasion.
	有真理　不用怕	With the truth We are not scared.
	殺敵絕不手軟	We face to kill our enemies.

大夥兒　來團結	All people should consolidate.
眾志必可成城	Our unity of will then is unshakeable.
每個人　一條心	When everyone is of one mind,
力量無比強大	Our strength is incomparable.
我們去當軍人	We want to be soldiers
奮力殺敵	To fight hard to kill our enemy.
不怕把命獻出來	I'm not worried for my personal safety.
終有天　敵敗退	One day Enemy be defeated
趕倭寇　去大海	Expelling Japs to the sea.
勝利來　齊慶賀	Victory comes Celebration.
勝利來臨　大家笑	Victory makes us glad.

對白
Dialogue

昇，一切準備好了！	Sheng, Everything is ready.
好，我們走！	Okay, Let's go.

第二場 Scene Two

> 背景：上海法租界百樂門大舞廳
> Background: The Paramount Ballroom

> 唱：（1）花世界、夜上海（4'20"）／（2）月影舞曲（2'52"）
> Songs: (1) Floral World, Shanghai Night (4'20")
> (2) Moonlight Shadow Waltz (2'52")

獨白 Rap talk	各位嘉賓， 歡迎來到百樂門， 我是這兒的經理，羅拔。	Ladies and Gentlemen, Welcome to the Paramount. This is Robert The manager.
	上海到處是黃金， 看你懂不懂怎做， 出來闖要有派頭， 雪茄在手信心足， 財源廣進靠把口， 玩世不恭有本領， 今夜除夕大派對， 貴客盡歡多打賞。 唉，舞廳經理不易做呀！ 面面俱全笑迎人，嗱！ 笑迎人！哈哈！	Shanghai has gold in all the places. Depends on how you make the cases, Struggling to survive needs some basis, A cigar in hand builds trust in mind. Money comes by with sweet words. Playing around needs real work. Great party on this New Year's Eve. Happy guests will give more tips. Sigh, my job isn't an easy one. Smiling to all like a shining sun, Smiling falsely to everyone, Ha Ha!
	今夜，為慶祝新年來臨！	Tonight, to celebrate the coming New Year.
	百樂門安排了豐富的節目，有化妝舞會、大型歌舞、倒數等等等等。	There are many programmes arranged by the Paramount; masquerade, ballroom dances, the countdown, etc.

首先，我們邀請茉利小姐
為我們獻唱一曲《花世
界、夜上海》，
有請茉利小姐。

First of all, we're grateful to invite Miss
Julie to sing a song for us 'Floral World,
Shanghai Night'.
May I invite Miss Julie?

歌詞
Lyrics

花世界　世界花
看花花世界
夜美麗　美麗夜
美麗夜上海
醉金紙　金紙醉
紙醉金迷碎
夢繁星　繁星夢
夢在繁星裡

Floral world Fancy world;
Floral fancy world;
Bonny night Night bonny;
Bonny Shanghai night;
Gold paper Paper gold;
Soul goes with all of those;
Starry night Dreaming stars;
Sweet dreams in the stars.

男癡心　俊朗男
癡心俊朗男
兒勾魂　美人兒
勾魂美人兒
來又去　去又來
來來去去多
夢留情　情留夢
夢迷夜上海

Crazy lad Lad handsome;
Crazy handsome lad;
Sexy lass Lass pretty;
Sexy pretty lass;
Come n' go Go n' come;
Coming n' going;
Dream with love, Love in dream;
Dreaming in Shanghai.

你來偷我的心
我來勾你的魂
沒心的可人兒
掉魄的小帥哥
今夜不許離開
一起來醉一回
緊抱你不放下
來吻我千百遍
醉臥蘇州河畔
夢中找尋真愛

You come to steal my heart.
I'll grab your drifting soul.
Lassie's heart has gone a'missing,
A lad scouring for his soul.
You can't leave me alone.
Having a drink together,
Let me hold you tightly,
And kiss you thousand times.
Drinking by the Suchow Creek,
Sweet dreams stir in love.

花世界　世界花
看花花世界

Floral world　Fancy world;
Floral fancy world;

夜美麗　美麗夜	Bonny night　Night bonny;
美麗夜上海	Bonny Shanghai night;
醉金紙　金紙醉	Gold paper　Paper gold;
紙醉金迷碎	Soul goes with all of those;
夢繁星　繁星夢	Starry night　Dreaming stars;
夢在繁星裡	Dreaming in the stars;
夢在繁星裡	Dreaming in the stars;
夢在繁星裡	Dreaming in the stars;
夢見夜上海　上海	Dreaming in Shanghai, Shanghai.

獨白 Rap talk	好，	Good
	節目多多娛賓客，	Many programmes are in place to entertain the guests.
	不如快步換舞伴，	Can't miss the quick waltz with partners in the quest.
	新鮮感覺人人愛，	A fresh feeling creates high spirits.
	盡歡今宵蜜蜜甜。	Happiness comes to making everyone, sweet and wild.
	今夜，我們非常榮幸能夠邀請到我們上海商會會長千金大小姐楊小姐為我們獻唱一曲《月影舞曲》，同時，也有我們駐場歌手查禮伴唱，	Tonight, we have the pleasure of inviting Miss Yang the daughter of the President of the Shanghai Chamber of Commerce to sing for us 'Moonlight Shadow Waltz'. In the meantime, our ballroom singer, Charlie, will accompany the singing.
	有請楊小姐，	May I invite Miss Yang?
	不要忘記交換舞伴。	Don't forget to change your partners.

歌詞 Lyrics	百樂門　星輝月	The Paramount of stars and moon;
	華麗滿堂	The opulent star hall;
	亮星空　星光閃	Starry skies Twinkling stars;
	星光月影	Starlight moon parade.
	愛有情　小夥子	I love him, He is mine.
	俊朗使人動容	Handsome, he moves me so.
	載歌舞　轉多回	We're waltzing Round and round,
	轉回夢裡雲端	Revolving in a sweet dream.

月色美　柔風送	Moon shadows Soft gentle breeze,
柔情樂韻	Music divine,
望天空　流星飛	Hark above The shooting stars,
劃破長空	Flare across the sky,
彩舞衣　美人兒	Dancing gown Bonny girl,
美貌不可天物	Whose radiance is like an angel.
載歌舞　轉多回	We're waltzing Round and round,
轉離繁華美景	Revolving in a fantasy.
我忽見愛侶咫尺	He comes so near,
似相隔萬里	But to me it's like he's still a thousand miles.
興奮快步舞	I'm waltzing quickly,
往懷送萬千般情	To hold her firmly in my arms.
相逢歌舞	Dancing again,
仿如隔世戀	Just like our previous love.
緊抱你懷中	Hold firmly to me.
心如鹿撞	My heart's throbbing.
幻影歌舞使人醉	In our fantasy dancing makes me drunk,
醉及時	Drunk in time.
人生得意需盡歡	Don't let joy be overcome.
哪管天長地久	Who cares about permanent time.
細享眼前風流情	Just enjoy this instant love.
我忽見愛侶咫尺	He comes so near.
似相隔萬里	But to me it's like he's still a thousand miles.
興奮快步舞	I'm waltzing quickly
往懷送萬千般情	To hold her firmly in my arms.
相逢歌舞	Dancing again,
仿如隔世戀	Just like our previous love.
緊抱我懷中	Hold firmly to me,
心如鹿撞	My heart's throbbing.
幻影歌舞使人醉	In our fantasy dancing makes me drunk.

醉及時	Drunk in time,
人生得意需盡歡	Don't let joy be overcome.
輕弄蠻腰細軟	Swaying slender hips;
釋出萬千般愛意	Fighting off temptation.
百樂門　星輝月	The Paramount of stars and moon;
華麗滿堂	The opulent star hall;
亮星空　星光閃	Starry skies Twinkling stars;
星光月影	Starlight moon parade.
愛有情　小夥子	I love him He is mine.
俊朗使人動容	Handsome, he moves me so.
載歌舞　轉多回	We're waltzing Round and round,
轉回夢裡雲端	Revolving in a sweet dream.
你是我的愛	You are my only true love.
今生愛不滅	Our love will continue on and on.
你是我的愛	You are my only true love.
今生愛不滅	Our love will continue on and on.
永不會離開	We'll never be apart.

第三場 Scene Three

> 背景：上海法租界百樂門大舞廳
> Background: Paramount Ballroom

> 唱：深思愛侶（3'21"）
> Song: Love in Deep Memory (3'21")

對白 Dialogue	太君。	Taichou.
	不錯。	Not bad.
	我找你找得好苦。	I've been looking for you all over.
	我也是。	I've been looking for you too.
歌詞 Lyrics	日升月落	Sunrise and moonset,
	宇宙循環不息	The Universe keeps on revolving.
	朝思夢想	Been thinking of you all day.
	你的愛意在心	Love you with all my heart.
	今天重遇	We meet again today.
	千言萬語怎說	There's nothing I can say.
	天地見證	With heaven and earth are witnesses to
	愛你今生來世	My love for you which will never ever fade.
	亂世之情	Love in a turbulent era.
	人命朝不保夕	Life is never secure.
	短暫歡樂	Snatches of momentary happiness.
	難掩離愁之苦	Can't appease the sadness.

深思愛侶	Love in deep memory
望穿秋水愛郎	With roots that bind it beyond faeries.
幸見郎歸	Now my love is here to stay.
柔情有所寄託	Fondly fondle the cradle to lay.
讓世界來停頓	Let the world stand still.
把你的笑留著	Keeping your smiles on me.
藏在我心底裡	Hide them in the bottom of my heart.
永遠是那麼美	Flourishing bonny enwrap me never to be apart.
說謊小夥子　騙人有情郎	A lying young lad Cheating me with a love dupe.
假的亦當真　永遠留在我心	Falsehoods presented as real To hook in my mind permanently.
我的心	To you I give
無私送給你	All my heart unselfishly.
給你的愛	The love I give
像月亮般皎潔	Is as clear as the full moon's shard.
亂世人	A man caught in a chaotic place
漂泊川野間	Wandering around but nowhere to go.
夜半夢迴　想回到你身旁	Dreaming of you at menacing midnight of being back by your side.
我的心	To you I give
無私送給你	All my heart unselfishly.
給你的愛	The love I give
像月亮般皎潔	Is as clear as the full moon's shard.
亂世人	A man caught in a chaotic place
漂泊四方	Nowhere to go.
夜半夢迴見你	Dreaming of you at menacing midnight.

對白 Dialogue	今天我很高興，我們要締造一個完美的世界，大東亞共榮圈是世界繁榮基石。	I'm very happy tonight. Rejoice in our new creation Greater East Asia Co-prosperity Sphere. It is the foundation stone for world prosperity.

52

不行， 你要趕快離開百樂門！	Listen! You have to leave the Paramount as quickly as possible!
為甚麼？	Why?
我有重要事情要辦， 你千萬不要跟來。	I have something important to do. Don't follow me!
這怎麼可以？	Why not?
後會有期。	See you soon sometime.

第四場 Scene Four

> 背景：上海法租界百樂門大舞廳
> Background: Paramount Ballroom

> 音樂：上海波爾卡舞（1'36"）
> Music: Shanghai Polka (1'36")

對白 Dialogue		
	各位，各位， 1938 年即將來臨， 那麼在來臨之際，讓我 們一起跳上海最流行的 波爾卡。	Hello everybody. The year 1938 is upon us. Before it falls Let's dance the Polka, Shanghai's most liked musical piece.
	音樂起——	Music.
	女兒，這位是大佐。	Girl This is the colonel.
	這是我的女兒，楊小姐。	This is my daughter Miss Yang.
	楊小姐，今天好漂亮， 我能請你跳只舞嗎？	Miss Yang, you're very pretty. May I invite you for a dance?
	各位，各位，各位， 零點的鐘聲即將敲響， 現在讓大家跟我一起倒 數 「10…9…8…7…6… 5…4…3…2…1」	Attention everybody! The count down to 1938 is about to begin. Let's do it all together! "10…9…8…7…6… 5…4… 3… 2…1"
	快跑！	Run fast and don't look back!
	別怕，別怕！	Don't be afraid Don't be afraid!

第五場 Scene Five

> 背景：蘇州河畔
> Background: Suchow Creek

> 唱／奏：晨露（3'44"）
> Song: Morning Dew (3'44")

對白 Dialogue		
	有沒有受傷？	Are you injured at all?
	沒有，你呢？	No. How about you?
	我也沒有。 太危險了。	No fortunately. That was a very dangerous situation we escaped from.
	嗯，你怕嗎？	Sigh Are you scared?
	我不怕。	No, I'm not scared at all.
	大敵當前， 我們中國人都該挺身而出，去戰鬥！	It's a big enemy we're facing. We Chinese must stand up and fight!
	自從四行倉庫離別之後，我很想念你！	I've missed you since we left the Sihang Warehouse.
	我也是，我每天都念你如晨露每天來臨。	Me too. Like the morning dew which welcomes each day.
	滋潤人間。	Not seeing you makes me feel blue.

戰火亡魂	The souls of the fires of war
漫山遍野游離	Drift in the fields and mountains helplessly.
無處為家	With no place to reside,
心中困窘難堪	Out of bewilderment and sadness with you it was.
一見鍾情	Love at first sight,
朝思夢想不休	I'm yearning to come to your side.
語寄晨露	Send a message with this morning dew,
光明可見	Brightness will return and life will spring a new.
每天早晨	Every morning,
我向蒼天禱告	I pray to heaven
能再見你	Longing to see you.
慰解寂寞的心	To heal my lonely heart from solitude.
清新晨露	A tiny drop of morning dew,
純真明珠甘飴	Purer than spring water,
看似小	That energies a body with freshness to vitality.
實生命之泉	My soul aches for your presence.
真的不明何解	I don't understand it.
弱女兒貞節勇敢送旗給國軍	A girl like you who is so brave to bring a flag to soldiers.
歎奈何你的父親甘為漢奸助敵	And yet your father is a traitor who works for the enemy.
我父光明磊落	My father is open and candid.
絕不會埋沒天良	He would never turn on his people or against heavenly virtues.
幹那沒良心　傷天理	He would never act to damage our people, God or country!
天地不容	
害國民的勾當	
他為何當偽政要	Why does he work for the puppet government?

這為勢權宜之計	That is only a temporary measure and it's something that's unavoidable for him.
啥為勢所逼	What do you mean by temporary measure?
啥權宜之計	And it's unavoidable.
你咄咄逼人	You're being a bid overbearing.
有沒有良心	You're not serious. Are you?
我義薄雲天	I like to stand up for what's right.
你　不可理喻	You're being stubborn and hard-nosed.
絕不會徇私	I won't bend my principles.
似牛皮燈籠	Like an ox-skin lantern.
義薄雲天　絕不徇私	I'm standing up for what I believe in.
牛皮燈籠	An Ox-skin lantern
點極不明	Cannot be lit.
義薄雲天　絕不徇私	I'm standing up for what I believe in.
牛皮燈籠	An Ox-skin lantern
點極不明	Cannot be lit.
你的態度　令我極悲傷	Your manner makes me sad.
我不是無情來傷你心	I am not trying to hurt you.
你為人正義可嘉	You are a righteous man.
不要固執信任我	Don't be stubborn and trust me.
只是想知實情	My dear
求個明白為愛你	I want to find out the facts.
對白 Dialogue　我真的不是有心來傷你的。	I don't mean to hurt you.

歌詞 Lyrics	亂世之情	Love in time of turbulence
	不能寄予奢望	Doesn't leave much room for comfort.
	樹倒傾巢之下	If you find a fallen tree containing a nest,
	豈有完卵	Do you expect to find unbroken eggs?
	望風輕歎	Looking to the breeze,
	情人會往哪方	Where does my love go?
	天各一方	To stay in separate places,
	寄情晨露	Messages can be sent by the morning dew.
對白 Dialogue	日本人肯定在到處搜捕你，	The wee Japanese are looking for you.
	你趕快離開！	You have to leave as quickly as possible!
	你也要小心啊！	Be careful!
	我有你的護身符！	I have your amulet!

第六場 Scene Six

> **背景：蘇州河畔**
> Background: Suchow Creek

> **唱／奏：他從天邊來**（3'13"）
> Song: Shuffling In The Sky (3'13")

歌詞 Lyrics		
在那遙遠的地方	At a fairly long distance,	
有人苦苦等候我	Someone's waiting to see me.	
不幸中途迷了路	I lost my way on the road.	
明燈照路把我送	A light shows me the way to go.	
天空中看見了你	In the sky I can see you.	
揮手迎風送吻來	Waiving your hand to say hello,	
俊朗面孔把我迷	Eye to eye we catch on fire.	
微風吹髮空中揚	Passion comes to us in time.	
你　時常令我笑	You always make me laugh	
滿嘴甜蜜語	With your sweet words.	
藏在心窩裡	Drilling in my heart,	
永記不能忘	Can never be forgotten.	
愛　柔情萬絲愛	Love, fondly tender love.	
令頭昏目眩	Swirling in my heart.	
有時使人悲	Sometimes makes me blue.	
激情往天飛	Sometimes throws me high.	
不要讓我灰	Please don't let me down.	
擁我在你懷	Hold me in your arms.	

来　来送你的爱　　　　Me, tell me you love me.
展示無遺　　　　　　　It's not a made-up line.
你是我愛人　共度一生　You are mine o mine throughout our life.
不管是在何方　　　　　No matter, wherever, forever
永遠地要共同一起　　　We will stay together.

在那遙遠的地方　　　　At a fairly long distance?
有人苦苦等候我　　　　Someone's waiting to see me.
不幸中途迷了路　　　　I lost my way on the road.
明燈照路把我送　　　　A light shows me the way to go
來尋你　　　　　　　　To be with you!

第三幕
以一敵眾

敏回家後，弟弟聰告訴敏不要進入屋內，因為有很多日本特務要敏父「交人」，他們指控敏參與暗殺日本大佐案件，敏父正與他們爭論。

敏進入屋內，看見父親受松下少佐威嚇。

敏母阻止敏進入屋內，敏不理會母勸阻，推開母親，跪在父親跟前，哭訴女兒不孝，拖累父親受苦，父女合唱《忘國恨》。

敏給松下少佐拘捕，敏父追出阻止，救女不遂，反為松下踢傷。

昇在蘇州河畔躑躅經過倉庫遇見茱利，茱利向昇表示暗戀他，兩人唱出《亂世姐弟情》，昇告訴茱利他只愛敏，但可惜敏父是漢奸。茱利向昇澄清敏父是地下黨戰士。昇對自己的主觀判斷錯誤羞愧萬分。茱利覺得敏會有生命危險，他們一起跑去找尋敏，到達時，方知敏被日本特務拘捕，傷心不已，為自己的無知而自責。

敏被松下少佐扣押至上海北四川路 491 號日軍憲兵總部。

犬養大難不死，在密室向敏嚴刑拷問，迫她交出兇手、背景等情況。

雙方唱《魔鬼代表》對答，敏唱出悲慘之音，寧死不屈，在嚴刑拷打下，不懼死亡，狂數日本軍侵略中國之可恨，人神共憤。犬養說話狂吠，強詞奪理。

犬養走過去行刑架前，拉起敏的頭，說：「你這麼美麗，何必為這個殺人兇手受皮肉之苦呢？我給你半小時，如果你還不告知誰是兇手，我會立即把你賜給看守門口的兩個守衛，他們正虎視眈眈地看著你，等著大快朵頤天鵝肉。」

松下把敏鬆開，臨走前加踢一兩腳，大力把鐵門關上。

敏滿身鮮血，躺在地上，很辛苦地爬起來，她知道今天必死無疑，唱出《死不懼怕》。

在重要關頭，敏父獲地下戰士和內應協助，攻打憲兵部，打破鐵門
從牢獄救人。茱利亦是地下黨戰士，帶領昇參加救人行動，槍殺犬養。

Act Three
The Courage

When Wendy arrives home, her brother John pleads with her not to
go into the house as many Japanese secret policemen have come to force
her father to hand her over to them. They accuse Wendy of conspiring with
the assassin who shot the colonel. Wendy's father naturally denies this and
disputes it with the police, insisting that his daughter had nothing to do with
it at all.

Wendy, however, sneaks into the house and from there sees her father
being harassed and threatened by Major Matsushita.

Wendy's mother also tries to stop her from entering the house, but she
defiantly brushes her mother aside, and rushes into the house. Once inside
she kneels in front of her father and laments, saying, "I totally lack filial piety
and these complications force you into such suffering!" Father and daughter
then sing 'The Grievance of Subjugation'.

Wendy is eventually arrested and taken away by Matsushita. Her father
rushes out trying one last time to save her, but it does not work; instead he
injures himself in the attempt.

Sheng wanders around the Suchow Creek and while passing by a
godown, he meets Julie, who is so relieved to find him. She tells him she
secretly admires him. They sing 'Tale of Comrades' Love'. Sheng responds,
saying he only loves Wendy and tells her that Wendy's father is a traitor. On
hearing this Julie begins to worry about Wendy whose life is at stake. They
immediately look for Wendy, only to be told that she has been arrested by

Matsushita. Sheng deeply regrets that his selfishness may have added to her pain and begins criticising and blaming himself for his stupidity and ignorance.

Wendy is seen handcuffed and dragged to the Kempeitai on 491 Szechuen Road North in Shanghai.

Inukai wasn't killed in the assassination attempt and, after hospitalization, made a full recovery. He and Wendy stare each other open-mouthed at this revelation, while singing 'Devil's Advocate'. Wendy shows no fear of death and sings in a sorrowful tones, strongly condemning Japanese military aggression and their invasion into China, causing both Heaven and Man to rage in great indignation against this travesty.

Inukai approaches the torture rack and pulls up Wendy's head, remarking, "You're very pretty; no point for you to endure and bear such torture for the would-be murderer. I'll let you have some time to think about it and when I come back, if you still keep your mouth shut, then I'll immediately hand you over to the two guards. They have been watching you intently, waiting to swallow you up!"

Matsushita loosens Wendy's shackles and kicks her before leaving the room, closing the iron door heavily behind him.

Wendy, soaked in blood, lies on the floor knowing that she has not got a chance to live and will soon be dead. Yet she tries hard to stand up to sing 'A Call To Death'.

At this crucial juncture, Wendy's father arrives with men in arms dressed in undercover clothes. They break open the iron door to rescue her from her captivity.

Julie, who is also an underground warrior, joins Sheng in the rescue operation, in which Inukai is shot death by Sheng and Julie.

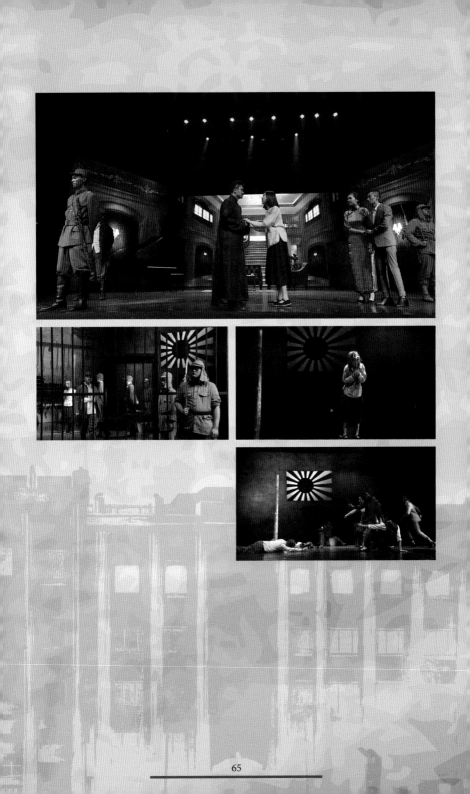

第三幕 Act Three

第一場 Scene One

> 背景：楊府大宅
> Background: House of Yang Family

> 唱／奏：亡國恨（2'38"）
> Song: The Grievance of Subjugation (2'38")

對白 Dialogue		
	把人交出來！	Hand over your daughter to us.
	太君，她不在。	Taichou She isn't here.
	今天要不把人交出來， 就把你帶走！	You have to hand her to us, Or I'll put you back behind bars.
	太君，她真的不在！	She isn't at home really.
	你想想！	Think about the consequences of lying to us.
	沒有？ 你想想！	No is your answer. Think about it seriously.
	敏。	Wendy.
	姐， 你別進去， 趕快走！	Sister, Don't go inside. Run away!
	怎麼了？	What's the matter?
	趕快走！	Run away!

怎麼了？	What's the matter?
日軍特務正在尋找你！	Japanese secret agents are here looking for you.
爹正在跟他們交涉。	Dad is being confronted by them now.
你想想！	You should think carefully.
不在。	She isn't here.
太君。冷靜。	Taichou. Calm down.
不，我一定要進去！	No. I must go in.
乖女，	Good girl.
你快快離開吧。	You have to leave.
特務看見你一定會把你拘捕！	They'll arrest you.
我不能連累爹，	I can't let dad get into trouble.
讓我進去！	Let me go in.
太君，冷靜。	Taichou. Calm down.
住手！	Stop!
敏，快跑！	Wendy, Run for your life!
想跑？	You want to leave?
我不會跑。	I'm not leaving.
刺殺大佐的兇手在哪兒？	Where is the man who tried to kill the Colonel?
你說誰啊？	Who are you referring to?
就在百樂門的陳查禮。	Charlie Chen who works at the Paramount.

我剛剛才在百樂門認識他，	I've only met him once.
我怎會知道他在哪兒？	How could I know where he is now?
你不知道？	You don't know.
你的，騙人！	You're a liar and a cheat.
來人！	Come on!
把她抓起來！	Arrest her!
嘿！	Sigh!
爹，女兒不孝，	Dad I am un-gracious,
連累爹爹了。	Involving you in this trouble.
不用怕，	Don't worry.
我會想辦法救你。	I'll try every means to save you.
太君，求求你，	Taichou, I beg you.
給我一些時間吧。	Please give me some more time.
求求你，	I beg you.
給我一些時間吧。	Please give me some time.
求求你。	Please…please.

歌詞 Lyrics		
	山明水秀日躲藏	Sun hides behind a wide silhouetted hill.
	迷懵景象月難開	Moonlight shrouded blindly in the mist side.
	群雁南飛不復來	Wild geese flying south of no return.
	無足小鳥空悲哀	A legless bird's crying to the sky.
	誓奪山河錦秀地	A determination to retrieve land and river.
	千年文化是吾根	A thousand-year culture is the root of my being.
	不能作為亡國奴	Never can we be the slaves.
	後庭花豔怎當真	Flourishing flowers in the backyard are truly fake.

自古由來皆知	Since ancient time,
人不能勝天	We know man can't win over heaven.
天必憐憫人	But heaven has pity on man.
殃殃大國民	As great nationals,
亡國情難堪	We can't accept enslavement.
犧牲不可免	Sacrifice is inevitable.
國難才可滅	The national crisis is to be overcome.
國難才可滅	The national crisis is to be overcome.
炮火隆隆來奪命	Gun fire cracking wide to take people's lives.
孩童哇哇哭震天	Children crying loudly through the sky.
軍民不懼把命送	No one dare to die,
誓取敵軍命來填	In our effort to take enemy's lives.
齊心協力	By working hard together,
還我錦秀山河大地	We can retrieve our beautiful land.

對白 Dialogue	帶走！	Take her away!
	太君，她是無辜的， 放過她吧！太君。	Taichou. She is innocent. Let her go! Taichou.
	爹。	Dad.
	你，你們……	You are…

第二場 Scene Two

> **背景：蘇州河畔倉庫（秘密基地）**
> Background: Warehouse (secret place) nearby the Suchow Creek

> **唱／奏：亂世姐弟情（2'21"）**
> Song: Tale of Comrade's Love (2'21")

對白 Dialogue		
來。	Come.	
這裡，	Here is the place.	
就是這個碼頭。	This is the pier.	
好。	Fine.	
組長。	Team leader.	
辛苦了。	Thanks for everything.	
組長。	Team leader.	
這批物資已經到了，	Our equipment has arrived.	
我們聯繫了這個碼頭。	I have contacted the pier master.	
茱利，這次的行動一定要保密，	Julie, we have to keep this operation confidential.	
我去向組織匯報。	I'll report to the organization.	
你守在這裡。	You keep watching here.	
好。	Good.	
注意安全。	Be vigilant.	
知道了。	Understood.	

	我先走了。	I'll leave now.
	茱利。	Julie.
	昇，你怎麼會在這裡。	Sheng. Why are you here?
	我要走了。	I have to go now.
	我來是跟你道別的。	I am here to say goodbye.
	你要去哪裡？	Where are you going?
	我要再次從軍。	I'm joining the army again.
	我們再見仿如隔世，曾經共生死。	We're lucky to meet again. We've been through life and death together.
	今天從死神手裡逃出來，我怕再沒時間把我的心中話說給你聽。	And we're both alive to tell the tale. I was worried I wouldn't have time to tell you these words from my heart.
	甚麼話？	What would you like to say?

歌詞
Lyrics

相處多時	Having known each other
並肩作戰	And fought alongside,
情深如兄弟	Our friendship is as deep as brothers.
倉庫大戰	In the combat at the Sihang Warehouse,
生死一線	Where life and death was but a shadow apart,
方知愛暗生	I knew that I loved you.
出生入死	We went from the cradle to the grave,
共聚沙場	Fighting on the same battlefield
難分雌或雄	Despite being of the opposite sex.
生死關頭	At that one critical moment,
捨命護我	You saved my life.
深明姐情重	I'm still deeply indebted to you for that.

神女有心		I give you my heart.
襄王無夢		But you won't accept it.
盼來世可聚		Hoping our love will continue in the next life.
心有所愛		I have another lover.
辜負姐情		I can't reciprocate your love.
不要責怪我		Please forgive me.
遇一知己		Even though we have this great love for each other,
無緣長聚　一生亦無悔		I realise we can't be together and I accept that.
姐姐機智		You are intelligent.
英勇善戰		You're well-versed in combat.
當今花木蘭		You're a highly trained female fighter.
戰地姐弟情		Our friendship is that of as close as sibling.
蒼天會庇佑		Heaven will bless us.

男女之愛，不能強求。	Love doesn't just happen. I know that.
那我……默默祝福你們，有情人終成眷屬。	And that's why I hope that you and Wendy will always be together.
哎，敏呢？不是跟你在一起嗎？	Sigh Where is Wendy? Isn't she with you?
敏她剛剛回家了。	She has just gone home.
對了，茱利，你知道嗎，敏的父親竟然是漢奸！	Right. Julie. Do you know that Wendy's father is a traitor?
漢奸？不！他是地下黨！	Traitor? No, he's not. He is a leading underground comrade.

地下黨？	An underground comrade.
對！我也是！	Yes. Me too.
他明是漢奸， 但他實際上一直掩護著 我們。	On the surface, he may appear to be. But, in fact, he does so much of our logistical planning.
原來是這樣，唉！ 我太無知了！	If that's the case, Sigh! I have been blind to the fact.
糟了！ 敏回家的話， 會給日本人抓走的！	Oh my God! If Wendy has gone home, She would have been arrested by the Japanese!
走！ 我們趕緊去救敏！	Let's go! We've got to save Wendy!
走！	Let's go!

第三場 Scene Three

> 背景：上海北四川路 491 號日軍憲兵總部行刑室
>
> Background: Kempeitai's Headquarters at 491 Szechuan Road North

對白 Dialogue		
	説不説，你説不説？	You have to tell me. Tell me now!
	閣下， 經特高科調查，	Your excellency, After our intelligence bureau investigated the attempted assassination,
	刺客是四行倉庫士兵。	They found that the person responsible was a soldier at the Sihang Warehouse.
	那個楊小姐就是給守軍送旗的人。	Miss Yang was the one who brought the flag there.
	他們一定認識的，不是初相識。	They must know each other from that time.
	嗯。	Sigh.
	你看見我， 很奇怪吧。	Look at me. This is very strange.
	有甚麼好奇怪？	What's strange about?
	你們一定以為我給擊斃了。	You thought I was shot dead at the Paramount on New Year's Eve.
	你的愛人槍法不準， 我也命大， 所以死不了。 告訴我，他在哪兒？	Your lover however was a lousy shot. I was lucky he missed. That's why I am still alive. Tell me. Where is he now?
	我不知道。	I don't know.

他叫甚麼名字？	What is his name?
我不認識他。	I don't know who you're talking about.
你別當我是傻子！	Don't treat me like an idiot.
不認識？	You don't know him?
我才不管你認不認識他！	I don't care whether you know him or not.
你只要告訴我在哪兒可以找到他，	Tell me where I can find him.
我就放你回家！	And I'll set you free.
再講一次！	I repeat one more time.
真的不認識他！	I really don't know him.
他殺人與我無關！	His assassination attempt has nothing to do with me.
你再嘴硬，	If you want to remain stubborn,
就休怪我無禮了！	Don't blame me if I turn nasty.

> **背景：日軍憲兵總部行刑室**
> Background: Kempeitai's Torture Room

> **唱：魔鬼代表**（4'01"）
> Song: Devil's Advocate (4'01")

歌詞 Lyrics		
	這世界　是弱肉強食	In the world today, it is the strong preying on the weak.
	失敗者　須臣服	The winner takes all and the loser is left but a shadow.
	大日本戰勝了	The great Japanese triumph has been to make the Chinese people obey them.
	依從我你們有福享	Only then can they have a sweet life.

魔鬼兒　狂生事端	Devils make trouble
多多藉口　來侵略	Which give them the pretext to invade and subjugate us.
我們雖然暫敗	Although we've been defeated,
睡獅給怒哮聲喚醒	The lion within has been woken up by our boiling anger.
識時務　為生存之道	Adapting is the way forward for survival.
不識趣	If you are not tactful,
必受苦	You will suffer at our hands.
大東亞共榮圈	Greater East Asia Co-Prosperity Sphere
將是世界繁榮基石	Will be the foundation of prosperity.
我不知	I don't know.
甚麼共榮圈	What is the Co-Prosperity Sphere?
只知道有真理	I only know the truth.
作惡者必自斃	Those that practice evil get caught out in the end.
有一天　必自嘗惡果	The devil must be rebottled.
你不要這麼兒頑強	Don't be so stubborn!
怎麼樣	What's the matter?
告訴我	Tell me!
甚麼事	Tell you what?
判亂分子	Find the would-be assassin.
我不知	I don't know.
我不知你説甚麼話	I don't know what you're saying.
給合作	Be cooperative.
怎合作	How?
找凶徒	Who is the rebellion?
我不知	I don't know him.

	一定要	You have to.
	找到他　放你回家去	I will set you free if you help me find him.
	魔鬼話	Devil words!
	誠心的	I'm being sincere.
	哪會有	How can I trust you?
	不知好歹	Do you know right from wrong?
	魔鬼	You devil.
	最終來個原形畢露	When will you unmask and expose your ugly face?
	怕打嗎	Aren't you afraid of being beaten?
	不怕打	No I'm not afraid.
	給我打	Give her a beating!
	打死不怕	No worries of beating me to death!
	打！打！	Beat! Beat!
對白 Dialogue	你説不説？	You must tell me!
歌詞 Lyrics	為甚麼你要祖護他	Why do you cover for him?
	他是你甚麼人	Who is he?
	甘為他受苦難	And why do you suffer for him?
	最終來死得不明白	In the end you'll die for no reason.
	我和他　患難中相識	I met him when Shanghai was first
	國家正處危難	invaded.
	不會怕	I'm not scared of you.
	不退縮	I'm going to stand my ground.
	更不降	I'll never surrender.
	打死也不説	I won't say a word even if you beat me to death.

喪心病狂惡魔	You are destructive devils.	
埋沒了良心作惡多端	Your conscience will burn with you in hell for the evil you've done.	
必……必有報應	You will be judged.	
天……天收惡魔	And heaven will meter out severe punishment for you.	
好一個硬嘴巴	You are such a loud mouth.	
臨到死還要趾高氣揚	Your arrogance in the face of death astounding.	
狠……狠心地打	My men will beat you fiercely.	
往……往死裡打	They'll beat you to death.	

> **背景：楊府大宅**
> Background: House of Yang Family

對白 Dialogue	老楊，	Mr Yang,
	情況我知道了。	I know what's going on.
	快請坐！	Please sit down.
	王部長。	Officer Wang,
	情況怎麼樣？	How's the situation now?
	我們已經找到了內線。	Our men are ready to move.
	無論任何代價，一定要將敏給救出來。	We must save Wendy at all costs.
	保證完成任務。	We must succeed in this mission.

第四場 Scene Four

> 背景：日軍憲兵總部行刑室
>
> Background: Kempeitai's Torture Room

> 唱／奏：死不懼怕（3'08"）
>
> Song: A Call To Death (3'08")

對白 Dialogue		
	你快點説！	Say!
	誰敢來刺殺皇軍，	Who tried to assassinate the Colonel?
	就是找死！	You're choosing certain death by not answering.
	松下君，	Matsushita,
	給我狠狠地打！	Beat her with all your might!
	你這麼美麗，	You are so pretty!
	為甚麼要替這個殺人兇手受皮肉之苦呢？	Why are you suffering for this would-be murderer?
	我給你一些時間，	I'll give you some time.
	我們會在半個小時後回來，	We'll come back in half an hour.
	如果到時候你還不告訴我誰是兇手，	If you don't tell me who the murderer is,
	我就把你賜給看守門口的兩個守衛，	I'm handing you over to the two guards at the gate.
	他們正虎視眈眈地看著你，等大快天鵝肉呢！	They are waiting to swallow you up!
	真不識抬舉！	Really stubborn!

79

生不逢時	I was born at the wrong time.
惡人當道	Evil holds the power,
到處殺人放火	Killing and burning all over the place.
大好中國美麗山河	Our magnificent land is under the fire of
慘遭無情戰火來洗禮	war.
我今受難	My life is one of destruction and despair,
有千萬人像我這樣受難	With many suffering like me everywhere.
一定不怕酷刑對待	The fear of torture hardly makes a dent
不流眼淚只流民族血	in the river of blood in which we sink or
	swim.
上天有情	The love from heaven,
人間見愛	The love from the Earth,
不用理	There's no need to despair.
生與死	Life or death.
貧與富	Poor or rich,
貴與賤	Noble or lowly.
誰能定	It matters nought wherever we are found.
我們不要懼怕	We aren't scared.
生死由來　由天註定	Life and death are destiny's fate.
今天我　為國家　灑熱	Today my hot blood surges for my
血	country.
死而無悔	Have no regrets if I live or die.
我不能去見心愛的人	I can't go to see my love.
但他心中長留我情	I know he keeps me in his heart.
這份深情的愛多美	This love is so beautiful.
不管怎麼轉變長留心間	No matter whatever changes I should
	face.
我今受難	My life is one of destruction and despair
有千萬人像我這樣受難	With many suffering like me everywhere.
一定不怕酷刑對待	The fear of torture hardly makes a dent
不流眼淚只流民族血	in the river of blood in which we sink or
	swim.

	我們一起來	We stand up to face
	去殺敵	And kill the enemy,
	保國家護山河	Protecting our country and resources.
	死不懼怕	We have no fear of death.
	從容去就義	And eagerly walk the tight rope between life and execution.
對白 Dialogue	閣下。	Your Excellency.
	犬養，	Inukai,
	你這殺人魔頭！	You are a devil,
	受死吧！	Go to hell!
	敏！	Wendy!
	快撤！	Let's run!
	閣下，閣下！	Your Excellency, your Excellency,
	啊，我要殺了你們！	Oh, I'll kill them!

第四幕
悲天憫人

　　一大群人逃入上海蒲石路天主教堂，幸好有仗義的神父幫助，逃過日軍憲兵追捕。

　　茱利冒死跑回敏家，帶敏母至教堂。敏母痛哭天不憐惜敏的遭遇，昇知敏受傷過重，將不久於人世，遂向敏求婚，若敏父母同意，願與敏結為夫婦，敏父、母點頭同意。

　　敏看著昇，非常感動，緊握昇的手。他們説：「我願意，請神父見證婚禮。」

　　敏、昇、敏父、敏母、神父配男、女高音七部聲唱《天使婚禮》。

　　婚禮儀式完成後，敏的情況更差，她爬起來，跪在父、母親面前痛哭：「爸爸、媽媽，女兒不孝，不能侍奉在您們身邊。我和昇已結為夫婦，我死後，希望昇能為我沐浴更衣，給我穿上繡上金絲孔雀的白色禮服，平安往天國。」

　　昇悲傷地安慰敏，表示能為她做任何事情。語畢，敏在昇懷中香消玉殞。在敏父同意下，各人離開教堂，留下昇為敏舉行一人葬禮。

　　深夜，教堂的墓地淒風苦雨。眾人離開後，昇摟敏軀狂哭，為敏進行一人葬禮，唱出悲慘歌曲《向上天哭訴》。此曲首段由結他伴奏，中段清唱，末段以弦琴伴奏，情節淒麗、壯烈、感人，昇唱至昏死。

　　上天憐憫他們，昇幻見敏變為孔雀仙女，眾人四重合唱《前世情人》。

　　敏告知昇來世情緣，留下孔雀羽毛作為來世見面信物，並會同一眾仙人唱《O' My Dream 我的夢》。

　　歌舞場面，昇、敏，仙人，歌舞表達無際天界，生命無常，愛永在。

　　眾人依輕快音樂，歡樂地載歌載舞至完幕。

　　大會謝幕。

Act Four
The Benevolence

The group flees into a Catholic church on Rue Bourgeat in Shanghai and manages to evade capture by the Kempeitai with the assistance of a priest who has an acute sense of social justice issues.

Julie runs back to Wendy's home without fear of death and brings her mother to the church. Wendy's mother is very sad and laments that Heaven has not answered her plea to save her daughter. Sheng, knowing that Wendy is dying from a deep wound that is beyond healing, pleads to marry Wendy. With Wendy's agreement, Sheng proposes to marry Wendy if her parents will permit it. In the end, her parents give their approval union between a man and a woman.

Wendy is so touched that she grips Sheng's hand tightly. They proclaim, "I do. Let the priest conduct the ceremony and bear witness to our wedding."

Wendy, Sheng, Wendy's parents and the priest together with choir then sing in seven voices, 'Wedding of The Angel'.

As the ceremony draws to an end, Wendy's condition deteriorates. She crawls along the floor on her hands and then kneels down on the floor, weeping bitter tears, saying, "I am undeserving and unfit to serve my mother and father any more. Now that I am wedded to Sheng, I hope when I die Sheng will wash me and dress me in a white evening gown embossed with golden peacock embroidery in order to speed me on my way to Heaven."

Sheng does his best to comfort Wendy, promising that he will do anything for her. As soon as he finishes saying this, she dies peacefully in his arms. At this point Wendy's parents and the rest exit the stage to allow Sheng to conduct a private requiem for Wendy.

It is a dark and rainy night and the church and the graveyard are shrouded in a cold foggy mist. Everyone has left except for Sheng, who holds Wendy's body tightly and wails uncontrollably. He conducts a solitary requiem for Wendy, ending with the loud singing of 'Wendy'. The movement starts with vocal and guitar, followed by a cappella. The movement ranges from sadness to burst of heroic splendor. Sheng becomes totally enmeshed in the music. Sheng falls into the fantasy that Heaven shows pity on them and the circumstances change. Wendy is reborn as a peacock angel. A choir of four then sings 'Destined Lover'.

Wendy tells Sheng that their love will resume in the next life and leaves him with a peacock feather as a token of their destined love. They gather around the angels and sing 'O' My Dream'.

The dance performance on stage depicts the miracles and imagination of the endless universe, the inconstancy of life and eternal love.

Everybody on stage dances and sings to signal the end of the musical.

Curtain Call.

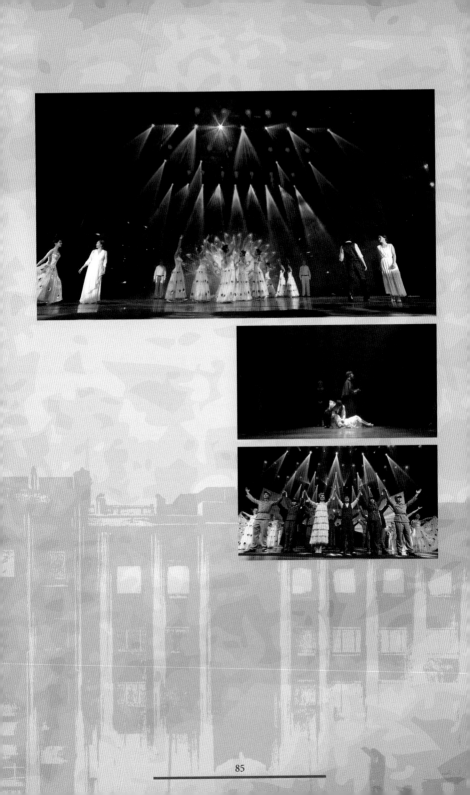

第四幕 Act Four

第一場 Scene One

➤ 背景：上海蒲石路天主教聖依納爵堂
 Background: St. Ignautis Catherdral, Shanghai

對白 Dialogue		
	來了！	They're coming!
	日本兵他們來了！	The Japanese soldiers are coming!
	嗯。	Sigh!
	你有沒有看到一群亂黨反賊來到這裡？	Did you see any insurgents coming in?
	沒有，	No.
	教堂是不會有亂黨反賊的。	There won't be any insurgents in the church.
	沒有？	No?
	我是明明看到朝這個方向走來，	I saw them running in this direction.
	你說沒有，你……	But you say they didn't come into the church. You…
	唉！	Sigh!
	你騙人！	You're a liar!
	搜！	Search the place!
	嘿！	Sigh!
	等等！	Wait!
	教堂不能隨便搜！	You can't search this house of God!
	搜！	Search every nook and cranny!

因父及子，及聖神之名者， 阿門。	In the name of the Father and of the Son and of the Holy Ghost, Amen.
阿門。	Amen.
報告，沒有。	Reporting, Nothing has been found.
閣下，沒有。	Your excellency, Nothing.
的確沒有。	Really nothing.
走！ 如果你發現甚麼可疑分子，記得告訴我，否則你跟反賊同罪！	Go! If you find any suspects, Report back to me, otherwise you will be charged like them.
他們會不會再回來？	Will they come back?
你去外邊看看？ 我去叫他們。	Go and see for yourself, I will call them.

第二場 Scene Two

> 背景：教堂
> Background: St. Ignautis Catherdral

> 奏：心破碎了（2'06"）
> Music: Broken Heart (2'06")

> 唱：天使婚禮（4'20"）
> Song: Wedding of The Angel (4'20")

對白 Dialogue		
	敏。	Wendy.
	姐。	Sister.
	敏， 我的女兒。	Wendy, My daughter.
	媽媽。	Mom.
	媽在。 先別說話，休息。	Mom's here. Don't speak. Take a rest.
	昇。	Sheng.
	我在。	I'm here.
	你要勇敢。	Be brave.
	你也是， 堅持住， 堅持住好嗎？	You too. Keep it up. It's better to stay active.
	姐。	Sister.

敏。	Wendy.
聰。	John.
你要聽話，知道嗎？	You have to listen to parents.
知道，我知道。	I know.
敏， 如果你願意， 我想在神父、伯父、伯母面前與你結為夫妻。	Wendy, With your agreement, I want to marry you before the eyes of your parents and the priest.
不行！	No!
為甚麼？	Why not?
我不能丟下你一個人！	I can't leave you alone!
我不管！ 只要能和你在一起， 哪怕只有一秒，我也願意。	I don't care! So long I can stay with you, Even for just one second longer.
嫁給我？	Marry me!
好。 我現在就為你們舉辦婚禮。	Good! Let me hold the marriage for you.

歌詞
Lyrics

您的來臨像天使到來	You came to us like an angel,
給我歡樂多喜悅	Giving us so much happiness and joy.
母親悉心照料您	Mother's taken good care of you,
給你美生活	Letting you develop into a beautiful thing.
疼您	We all love you.
家人看見你漸漸長大	We've watched you grow up gradually.
美麗樂觀有愛心	Pretty, optimistic, and with love.
老師時常讚美您	Your teachers always praised you.
照顧老弱人	You looked after the elderly and the weak.
乖女	Good girl.

我自幼受父母萬千般寵愛

I was spoiled by my parents who showered me with love.

不知天多高地可有多厚

I don't know how high the sky and how thick the earth is.

犯了錯媽媽不問情由必來護我

I've made mistakes but Mother never queried them but protected me from harm.

爸爸亦沒奈何

Father couldn't get a look in for Mother had already done it.

長大後知世界很多苦難人

When I grew up I discovered the suffering many people endured.

沒有愛沒有人關懷呵護

Alone, without care or love.

我要用媽媽給我的愛心愛他們

I felt I had to love them like a mother.

身為母親

As your mother,

看見你結婚

I'm glad to see you marry.

喜悅之情

It adds to my happiness.

表露無遺

You can see it in my face.

每個人　誠心地祝福

Everyone's truly blessing you.

嫁有情郎

Marry with your lover.

他必定深愛您

He must love you deeply.

愛您一生一世

May you love each other forever.

天上星

Stars in the sky,

雲邊月

Moon on the kirk side,

齊來祝賀您新婚

Blessing your marriage,

柔柔月色閃閃星

Soft moonlight in the shadow of twinkling stars,

送上愛心萬千個

Sending you thousands of hearts.

每個心　表示愛

Each heart represents love.

愛你仁慈友善

To add to your benevolence.

您記著　天有情

Remember that heaven is kind.

人有愛勝萬金

A man with love in his heart is worth much more than a bag of gold.

為甚麼您來主教堂	Why did you come to the church?
您帶了甚麼到來	What have you brought?
主不要金	God doesn't want gold.
主不要銀	God doesn't want silver.
主要您的誠心	God only wants your heart.
誠心誠意去祝福新人	Bless this couple with your heart.
無私地奉獻您的愛	Offer your love to them.
主耶穌基督　見證敏和	Lord Jesus Christ witness Sheng and
昇今成為夫婦	Wendy as husband and wife.
聖潔情　聖靈心	A sacred love comes with a pure heart.
情心永結受人愛	One's love and heart are mixed with pure joy.
沒有怨恨沒有嗔	No more hate, no more sadness,
只有愛心萬千個	Only thousands of heart.
每個心　表示愛	Each heart represents love,
愛您仁慈友善	To add to your benevolence.
您記著　天有情	Remember that heaven is kind.
人有愛勝萬金	A man with love in his heart is worth much more than a bag of gold.
我今天真幸運	I'm fortunate today.
得到你的愛	To have your love in me,
不用慌	Nothing to worry about,
不會怕	Nothing to fear.
只要你常在	While you're always here,
不怕艱苦	No difficulties arise.
全心全意愛你	With your love in my heart,
給你美好家	Giving you a good life,
給你多娃娃　給你我的所有	To raise a good sized family.
願國家富強起來	And build the country back to strength again.
歡樂和平家	Happy happy families.

只要您同在	As long as you're here,
只要您愛我	As long as you love me,
甚麼都不怕	I don't have fears any more.
漫長路	The long winding road,
有您在身邊	With you by my side,
如明燈照耀	Is brightly illuminated,
永遠展光彩	Shining forever from within me.
您的來臨像天使到來	You came to us like an angel,
給我歡樂多喜悅	Providing us with happiness and joy.
今天您為人媳婦	Now you as a wife,
把愛無私地給他	Devote all your love to him.
為人媳婦	As your wife,
持家必然要有道	I'll keep home warm and orderly.
同甘苦	To share our delights and hardships,
日出而作夜休息	Arise when the sun comes up and rest after it goes down.
喜悅心	My happiness
不是筆墨可形容	Cannot be described in words.
深愛您	I love you deeply.
愛您	Love you.
阿門	Amen.
阿門	Amen.

第三場 Scene Three

> 背景：教堂
> Background: St. Ignautis Catherdral

> 唱／奏：Wendy（向上天哭訴）（3'47"）
> Song: Wendy (3'47")

歌詞 Lyrics		
	您飛去七重天	Thy soul flies to heaven.
	我望空哭泣	Tears drop from the sky.
	永遠不能見您	Never let me see thee thus,
	我的心破碎了	Oh my heart smashed in two.
	怎麼辦呢	What can I do?
	讓我吻您多一次	Let me kiss thee once more.
	我要抱緊您在我懷抱裡	I long to hold thee in my arms.
	安撫我心靈	Heal my aching soul.
	噢　Wendy　我愛	Oh, My Love, Wendy.
	讓您的心引導我魂魄	Let me sew thy heart to my lost soul.
	帶我往下一世與您同在	Transport me too to the next life to be with thee.
	在春天裡	In the green Spring,
	花開遍滿山坡	Flowers caress the mountain.
	在夏天裡	In the hot hot Summer,
	小鳥飛翔天空	Eagles fly high in the sky.
	秋天風　舞弄下金樹葉	Autumn winds and floating golden leaves,
	冬天雪　令我悲傷	Winter snow make me so sad.

淚如泉湧	Tears pour out,
對著蒼天狂哭	Crying to the heavens.
淚如泉湧	Tears pour out,
對著蒼天狂哭	Crying to the heavens!
對著蒼天狂哭	Crying to the heavens!

第四場 Scene Four

> 唱／奏：前世情人（2'07"）
> Song: Destined Lover (2'07")

歌詞 Lyrics	您是前世情人	You are my destined lover.
	麻煩不會再臨	Troubles are gone forever.
	很快我們重聚	We must stay together.
	雖然空間不同	Though we are in two worlds,
	我夢見您說苦甜的話	I dream of you with sad sweet words.
	苦的細語令我哭	Those sad words wet my eyes.
	用火焰心來吻我	Come to kiss me with fire.
	噢　擁抱我　盡情擁抱我	Oh hold me tight, with you so near.
	小伙子	My handsome lad, my o mine.
	我是您的弱小心靈小情人	I am your wee lassie.
	吾愛　不要來傷心哭泣	My love, don't cry.
	無限情愛　無邊天際	I fly to your side.
	無盡宇宙　無常時空	Deeper fondle, harder bubble, little tornado.
	能達無人世界	Blowing me to your side,
		Hold you tight.
	您是前世情人	You are my destined lover,
	每天都想念您	Thinking of you everyday,
	全心地去愛您	Loving you with all my heart.
	雖然我們分開	Though we are apart,
	我會去來世等著您	I will fly to you one day,
	小伙子	In my own ways.

小伙子　令我心愛牽掛	You, young lad, my love.
萬分	I cry, oh my young lad o mine.
小伙子　強壯如牛的您	You, strong as a tiger.
保護我弱小心靈	Heal me with fondness.
	In heart, aye, lad,
悲　我的離開令您哭	Sadly, I fly away, makes you cry.
喜　我很快回來擁抱您	Gladly sooner I come to your life.
我想念您的愛意和無比	My handsome young lad, destined lover,
溫柔的真情	Fondly fondle deep in my heart.
在這生沒人能像您給我	Mine oh my handsome young lad,
如海深情	I love you with all my heart.
小伙子	You young lad, my luv,
令我無盡牽掛的小夥子	I cry oh my young lad o mine.
您是我前世情人	Mine oh my handsome young lad,
下世很快會重遇見	My destined love oh my lad mine.
小情人　您在哪裡	You, lassie, my luv.
為甚麼不看我	I cry, oh my wee lass o mine.
你是否在天空邊	You, like roses bonny.
自由自在飛翔	Heal me fondly.
天與地祝福您重生	In heart, aye, lass,
我快樂等待再遇您	Sad, you're flying away has watered my
我要把您心留住	eyes.
每分每秒都要想您	Glad, sooner you come back into my life.
我要在夢中吻您	My bonny lassie, destined luv,
您是我前世情人	Fondly fondle deep in my heart.
在時空中遇見	Mine oh my bonny lassie,
您也把我心留住	You lassie my luv,
不要忘記我	I cry oh my wee lass o mine.
我愛您	Mine oh my honey lassie,
	My destined luv mine oh my lassie.

前世情人　美麗的天使	O mine o my wee lassie o mine,
時常在我身旁	Feeling you around me,
讓我看您心和潔淨身軀	Show me your heart, your body bare.
柔風吹耳説甜言	Blow in my ear, whisper sweet words,
不聽悲言賺人淚	No more sad words, they sadden me more.
來動我吧	Come heal my life instead of
讓小刀刺進心	Throbbing my heart as if chopped by a knife.
快感動容	Tearing it to pieces.
來　閃爍的鬼火	Come! Will-o'-the-wisp.
燒我成飛灰	Burning me to ash.
盡入您身中	Sucking me within you.
我求您不要遠走	I beg you not to set me free alone.
離棄飛往不明時空間	And show no mercy to me.
我已瘋狂愛您	I am crazy for you.
不能在這等候	No more waiting and expecting.
仰望星際天空	My eyes wide open to the sky.
找尋你的蹤影飛往找您	Looking for you, to have you by my side.
前世情人　美麗的天使	O mine o my wee lassie o mine,
時常在我身旁	Feeling you are here.
讓我看您心凄美動人臉	Nothing can stop my loving you deeper and dearer.
永遠等待　小情人	My love mine, oh my lassie.

第五場 Scene Five

> 唱／奏：O' My Dream 我的夢（3'39"）
> Song: O' My Dream (3'39")

O' My Dream	O' My Dream,
我的夢	My sweet dream,
你和我	You and I,
在夢中	In the dream.
O' My Dream	O' My Dream,
我的夢	My sweet dream,
你和我	You and I,
在夢中	In the dream.
你的美影常在	Your shadow
午夜夢迴來臨	Comes adrift to my dream.
交織萬般恩情	Weaving skeins of love
長留心中永記	In the memory of my heart.
藍天千里無雲	Blue skies cloudless and bright,
青山萬丈有勢	Yonder green mountain a spectacular sight,
怎可比對你思念	Can't come near expressing how much I miss you.
你的愛	Love to me.
你的愛	Love to me.
你的愛常在	Your love is always in me.
我愛你	I love you.
我愛你	I love you.
我永遠愛你	I'll love you forever.

大家團結力量來	Consolidating our strengths,
驅敵離黃土大地	Expelling the enemy from our land.
重建美好的家園	Rebuilding out home.
再遇歡樂美時光	Happiness returns.
喜見全民起來	Glad to see the people rise up
保衛壯麗山河	Protecting their land.
光輝照耀我們	Glory shining down upon us
同心協力前進	Striving to march ahead.
中華兒女齊心	Our hearts are in tune again
齊為勝利歌舞	Dancing to victory.
我們齊向世界唱	We're singing to the world.
沒戰爭　見和平	No more war, peaceful world.
和平仁愛世界	Peace and love to the world.
美世界　愛世人	Loving world, loving all.
和平仁愛世人	Peace and love to all.
O' My Dream	O' My Dream,
我的夢	My sweet dream,
引領光明路	Leading us to glory.
沒戰爭　見和平	No more war, peaceful world.
和平仁愛世界	Peace and love to the world.
美世界　愛世人	Loving world, loving all.
和平仁愛世人	Peace and love to all.
O' My Dream	O' My Dream,
我的夢	My sweet dream,
引領光明路	Leading us to glory.

第六場 Scene Six

> 背景：謝幕
>
> Background: Curtain Call on stage

> 字幕鳴謝
>
> Compliments

> 奏：流水行雲（2'12"）
>
> Music: Duet (2'12")

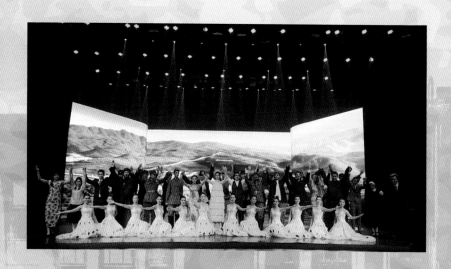

~ 全劇完 End ~

歌曲目錄 Song List

第一幕 Act One

1. Overture
 前奏曲
 (C-1261803395/ISRC: HKE491411023)

2. School Song
 勇者呼喚
 (C-1260876076/ISRC: HKE491411017)

3. The General's Order
 行動命令
 (C-1260876061/ISRC: HKE491411018)

4. The General's Order (Music)
 危機四伏（純音樂）
 (C-1261393533/ISRC: HKE491411010)

5. Where Are You (Music)
 尋找（純音樂）
 (C-1265989712)

6. Shuffling In The Sky (Short)
 他從天邊來（短）
 (C-1261803422/ISRC: HKE491411030)

7. Flamenco Firebird
 佛朗明哥火鳥
 (C-1260876084/ISRC: HKE491411019)

8. Brave Girl
 勇妹
 (C-1261803221/ISRC: HKE491411022)

9. Air Attack (Music)
 空襲（純音樂）
 (C-1265989751)

10. Life & Death Love
 生死戀
 (C-1260241224/ISRC: HKE491411001)

11. Bayonet March
 刺刀進行曲
 (C-1260876053/ISRC: HKE491411020)

12. Hero March 英雄進行曲
 (C-1260241762/ISRC: HKE491411007)

第二幕 Act Two

13. Peacock Dance (Music)　　　(C-1260241793/ISRC: HKE491411011)
孔雀舞（純音樂）

14. Soldier Blues　　　(C-1262685243/ISRC: HKE491411035)
軍人心聲

15. Floral World, Shanghai Night　　　(C-1260241506/ISRC: HKE491411004)
花世界、夜上海

16. Moonlight Shadow Waltz　　　(C-1260241514/ISRC: HKE491411005)
月影舞曲

17. Love In Deep Memory　　　(C-1261802593/ISRC: HKE491411029)
深思愛侶

18. Shanghai Polka (Music)　　　(C-1262685073/ ISRC: HKE491411031)
上海波爾卡舞（純音樂）

19. Morning Dew　　　(C-1261803124/ISRC: HKE491411025)
晨露

20. Shuffling In The Sky　　　(C-1260241391/ISRC: HKE491411002)
他從天邊來

第三幕 Act Three

21. The Grievance of Subjugation (C-1261803260/ISRC: HKE491411021)
 亡國恨

22. Tale of Comrade's Love (C-1262685220/ISRC: HKE491411034)
 亂世姐弟情

23. Devil's Advocate (C-1261393796/ISRC: HKE491411026)
 魔鬼代表

24. A Call To Death (C-1261803283/ISRC: HKE491411028)
 死不懼怕

第四幕 Act Four

25. Broken Heart (Music) (C-1262685204/ISRC: HKE491411033)
 心破碎了（純音樂）

26. Wedding Of The Angel (C-1261393781/ISRC: HKE491411024)
 天使婚禮

27. Wendy (C-1260241402/ISRC: HKE491411003)
 Wendy（向上天哭訴）

28. Destined Lover (C-1260241770/ISRC: HKE491411008)
 前世情人

29. O' My Dream (C-1261803012/ISRC: HKE491411027)
 我的夢

30. Duet (Music) (C-1262685115/ISRC: HKE491411032)
 流水行雲（純音樂）

新書預告！

今年我集中精力去完成音樂劇《1937 戰火忘情》的創作，並把全劇拍成電影發行播放，希望大家喜歡它。

該音樂劇是緣自創作中的小說《戰火忘情》，內容是描述中國人在 1930 年代日本侵略上海的艱辛歲月。小說以中、英文書寫，適合不同讀者需要。

陳見宏

2016 年 6 月

My novel is coming!

This year, I've devoted all my efforts on the development of the musical '1937 – The Lost World's Love'. Now that it is in a video film format, and due for imminent release, I would like to present you with some more information for better understanding of the time and place where the action happens.

The musical itself comes directly from my novel 'The Lost World's Love' which details the struggles the Chinese people had to endure under the Japanese occupation of Shanghai in late 1930s until the end of the World War II. The book will be published in Chinese and in English respectively.

The following is an introduction from the novel that leads directly to the heart of what drives the musical.

Simon Chan

June 2016

戰火忘情

小説部分章節

淞滬戰役

上海，一個令人醉生夢死，既婀娜多姿、自命不凡，又詭異莫測的城市。就像一位絕色佳人，度過無限風光歲月，亦經歷過很多艱辛時刻，卻又一如既往地展現出無盡魅力，更是冒險者的樂園，有著數之不盡的機遇。另一方面，街上亦充斥著多如過江之鯽的心碎落魄人，不管你如何待之，上海自有她的夢想——天賦推動力，充滿幻想，使人迷醉；其超凡毅力與膽識，令她從容逃過日本軍國主義的魔爪，元氣不虧，實乃不敗之都！

日本軍國主義者侵佔東三省，中國學生在上海發動大規模示威抗議。一九三七年一月二十八日，日本海軍轟炸上海，中國軍隊全力保衛上海，經國際周旋下，中日簽署停火協議，但不久之後，日方在同年五月單方面撕毀協議，戰爭又再爆發。一九三七年八月十三日，日本發動舉世震驚的「淞滬戰役」，國軍於十月二十六日奉命死守四行倉庫最少四天，以牽制日軍部隊前進。四行倉庫位於蘇州河畔南，鄰近公共租界，我們警衛連沒有在最前線作戰，主要是保衛作戰指揮部、通訊和提供支援彈藥、物資、補給物資予各前線作戰部隊。

此刻，狙擊手正在高點埋伏，射殺接近倉庫的日軍。

連隊上尉老爹粗聲大氣，叫：「昇，快過來。」

我快快跑去，立正答道：「報告，長官。」

雖然我站立不動，眼眸卻在四處觀望，腦海中想著到底何事如此緊迫。

老爹睨了我一眼，説：「靠近我躺下來，難道你想項上人頭給小日本狙擊手射上幾個窟窿，弄得稀巴爛的，瞬間皮開肉綻了？」

他接著説：「一營指揮官通知我，要保衛執行特別任務的女童軍。」

我瞇著眼地説：「女童軍？」

「閉嘴！你這色情狂！女童軍是來執行神聖任務的！」

我滿面通紅，有點兒尷尬地問：「神聖任務？」

「呸！」老爹吐了一口濃痰，然後説：「不錯，她會送我們一面國旗，以激勵士氣，希望那些該死的記者多寫一點對這場戰爭的看法。」他接著很快又説：「莫正在外頭狙擊日本鬼子頭，你叫他掩護你過河。」

他睜大眼睛、惡狠狠的吩咐道：「注意安全，不要讓女童軍受傷，否則用手榴彈把你的祠堂炸掉！」

「知道，長官，保證完成任務！」我敬禮應諾後便轉身離開。

老爹卻在背後大聲喊道：「注意橋上和租界的異常舉動，帶多些手榴彈！」

「知道，長官。」我邊跑邊回頭大聲應道。當下，心中一片雪亮，我深知這次行動非常危險，故儘量伏在地面走動，像老鼠般在倉庫頂爬行。莫見我匍匐過來，立刻緊張揮手示意我爬過去。

「噓！」他舉起手指，放在嘴上，示意要我保持肅靜；抬眼一看，只見一名小日本正在橋下，恰恰是射程之內。莫登時眼睛發亮，面朝河流，睨著我低聲道：「當我轉移，你要跟著做，否則你便報銷了！」

就在不久前，雙方還在激烈交戰，現時環境比較沉寂；天還未亮，敵我兩軍都沒有任何動靜。

「澎！澎！」莫向河中目標開了兩槍，只見一隻海鷗受驚從水中飛上來。

「傻子！快動！滾到我身邊！」莫大叫道。原來當我移動時，子彈就像流星在我頭上飛過。

「滾！滾！滾！」莫再次大叫，我們很快便轉移多個位置，直至安全地躲在沙包後。

射擊過後，一片死寂。莫抱槍在胸前，氣喘吁吁地說：「傻子！你幾乎命喪日本鬼子的狙擊手槍下了！因為你已暴露了自己的方位！」急喘了一口氣後，他又說：「你到底來幹甚麼？」

「老爹要我保護女童軍來戰地，著你掩護我逃過小日本的狙擊。」看莫的神色，估計是我的話令他疑惑，聽不懂我說甚麼，因我只用了三言兩語來轉述老爹的話。

「你不能出去。」

「為甚麼？」

「聽我說完再問，可以嗎？」

我點頭。

「在貨倉裡，不單有我軍士兵，亦有其他職員和工人。」他停下來往河上望了一眼，隨著他的視線，我看到橋上有人奔跑，然後忽地跳進河裡，很快便消失了。

莫續道：「這是我想告訴你的事情，在戰爭中，有些平民會從倉庫往外逃命。當然，我軍不會射殺他，因為他是中國人，就連日本鬼子都不會射殺他。」

我一臉疑惑地看著他，他說：「我說簡單點，小日本不想因為殺平民而暴露方位，而非出於仁慈或尊重生命。」

「哦，原來是這樣。」我點頭認同。

「所以，我要你轉換民裝，在貨倉內，有工人擺放衣服的房間，那兒有合適的衣服，穿上它，小日本應該不會再瞄準你來射。」

他看了一下我的槍械説：「你不能帶長槍和手榴彈。我給你密林手槍和子彈，方便攜帶，也要帶上小刀傍身。當你到達貨車場時，我會掩護你渡河，但是切忌回頭看我，那會暴露我的位置。你自個兒尋路去河邊，別在橋上走動，只有狗才會在橋上亂跑。如果你不照著我的話做，就會成為狙擊目標。過河後就是租界，小日本不敢在租界上殺人，那時候你就可安心去尋找女童軍了。」

「記得飯店名稱『匯中』嗎？我想她應該在那地方等你。見到她後，你要説你來保護她去貨倉送旗子的；回來可以泗水，或在橋下沿著支柱攀爬，橋下沒有日本鬼子，應該比較安全。萬一真的不幸遇上了，除非形勢十分危急，否則你要除掉他，一定不能用槍，須用刀子去解決。」

我非常感激莫給我的指點。然後我便換上民服，把手槍放在腰帶內，子彈和小刀放在身上。

他與我握手時説：「記著不要回頭看我，我來掩護你。」

當下，我再難自控，一下子淚流滿面，切切實實地感受到生死與共的情誼。他輕輕拍了拍我的背説：「小伙子，老爹瞭解我，所以叫我來保護你完成這任務。這事十分重要，那不僅僅是一面國旗，它代表的是要向全世界宣告，中國人有多勇敢！我們從不懼怕那些無恥的侵略者，作為士兵，我們要保護每一位人民能在這片樂土上生活，所以我們定要打勝仗！」

他繼續説：「去、去！不要回頭望！」這動人的時刻令我熱淚盈眶，然時不與我，只能強忍洶湧的情感，轉身向樓下走去。

➤　**一見鐘情**
戰士陷地顯真情　　情緣暗結定終生
無盡勇氣保大地　　赴湯蹈火尋愛侶
初遇少女愛慕生　　戰火無情人有愛
命運註定難一起　　翻天覆地驚人舉

戰火忘情

走到樓下時，我遇見了另一位戰友——大腳。我告訴他，我正要往租界進行特別任務，約一小時就能回來；若能趕在日出前完成，讓晨光照耀新日子的來臨，便可先聲奪人。

他提醒我說：「要注意租界巡捕房，如果他們知道你是士兵，又攜帶槍械，一定會拘捕你！」又續說：「當你回到貨車場時，得先停下來，在那些空置、破爛的保衛亭中等候我的訊號，然後才可移動。」

謝過大腳的幫忙後，只見天際仍然黑暗，月色黯然，貨車場殘破不堪，國軍部隊誓死戰鬥到底，保護控制這重要據點，幸好這據點是在公共租界人士眼皮下，小日本部隊不敢使用化武或者重型武器，使雙方軍隊在較接近的軍力下戰鬥。

到達貨車場外圍，我如小老鼠般疾走至破壞的貨車場旁，只見莫射殺的兩名小鬼子依舊伏倒河邊。雖很想走過去踢上兩腳才甘心，但因有任務在身，終未能趁機發洩心中怒氣。

對我來說，在橋底支柱上攀爬是輕而易舉的事，故很快我便到達外灘。找到南京路後，外國人的首選——匯中飯店，已是近在咫尺。因為天還未亮，在馬路上走動的人不太多，不遠處有上海巡捕房設立的檢查站，檢查來往市民；我想，找尋一位素未謀面的女童軍雖然不難，但亦是一項挑戰。我在腦海中嘗試描繪她的模樣，唔……應該是女學生吧？

正當我在附近觀察時，忽聽到一把孩童的尖細聲音，問道：「你……在找尋甚麼？」只見發問的人滿臉稚氣，年約十四歲，高個子，聽口音是道地的上海人。眼見男孩還在看著我，於是我壓低聲音回答：「是呀！」

他示意我跟著他，當我們走近飯店的一扇側門，或許是飯店廚房的出入口，他再次小心地觀察我，似對我有些怯懼。

我說：「不用擔心，我來找女童軍的。」

他立即變得很高興，叫道：「啊，姐姐，有人來接你！」

話音剛落，拐角處便走出一位像雕像般完美的少女，我頓時眼前一亮。她有一把烏黑油亮的長髮，身穿剪裁合身的女童軍制服，個子不算高，約五呎四吋左右；桃粉色的臉，齒如含貝，娉婷中略帶嬌羞。我覺得她也在注意著我，當下不禁自戀地想起，老爹常說，就算我穿得再破爛，仍然一派魅惑帥氣。這些思緒彷彿電光火石般，一下子注入腦子裡，令我不知時光流逝。

　　她自我介紹，閨名為「敏」，然後又指著身旁的男童說：「他是我的弟弟，『聰』。」她又續說：「部隊指揮官告知我，有人會在匯中接應，來回倉庫估計需要一小時。」

　　聰一臉驚恐，十分擔心姐姐在這次行動中遭遇不測；登時淚眼汪汪，緊握著她的手說：「你一定要安全回來。」

　　我拍他的肩膀說：「娃娃，我一定把你姐姐完好無缺的帶回來，一根頭髮都不會少！」

　　離開時，敏叮囑道：「聰，不要到處亂跑。必要時定要避開巡捕，我很快回來。」

　　我問她帶了甚麼，她答道：「我帶了國旗、繩索和小刀。」

　　「喔，繩索是頗有用的，你可否交給我？」然後我告知她接下來的行程計劃：「首先經大橋前往倉庫，鐵哥們已清除該位置的日軍。」稍稍停頓後又接著說：「我們不能從橋上走過去，因為很容易便會成為射擊目標，我們要在橋底爬過去。記著，當我們走到對岸時，你儘量要靠近我的背後，待我收到訊號才能繼續向前走。」

　　說罷，我建議用那條繩索把我們緊緊地牽繫在一起，免得走散；又不忘提醒她可能會見到屍體，切忌因害怕、驚慌而生出動靜，否則將引起敵軍注意。

　　她肯定地點頭，示意明白。

　　之後，我們便如蛇般爬行，儘量伏低身子、貼著地面。她緊握繩索的一端，而我拿著另一端；不想在這危機四伏的關頭，這丁點連繫竟帶

來奇妙感覺，當我們抵達橋底時，我禁不住回頭望了她一眼，卻見她臉上染上兩團紅霞，羞人答答。

我輕聲問道：「害怕嗎？」

只聽她的聲音羞得細如蚊吶，答道：「有你在……我不怕。」

眼前的敏吐氣如蘭，信任的話語伴隨著香水般的甜蜜氣息，彷彿抽走了我胸腔中的所有空氣。可是，這次任務至關重要，我絕不能因心生綺念而分神！此事生死攸關，兩條人命在我手上，絕不能掉以輕心，一秒都不行！我對自己說：「現在只要集中精神攀爬橋架，照應她之餘也要視察情況，然後慢慢前進。」

感覺到她向我靠近，我轉頭問道：「有事嗎？」

瞬間，我倆的臉近得幾乎要貼在一起。

她頓覺唐突，立即閉上了眼睛，卻又慌道：「屍……屍體！」

我安慰道：「不用擔心，那日本鬼子已經死了。」她點頭，看起來卻仍心有餘悸；眼看她的虛怯，我腦子裡衝動得真想跑過去，朝日本鬼子的屍體踢上兩腳洩憤。

當我們走近荒廢的警衛亭時，忽聽敏尖叫一聲！我連忙摀住她的嘴巴，全然不知她出了何事。原來，她看見那位日兵還未死去，正躺在地上蠢蠢欲動，只待我們靠近，便會用槍對付我們。我直覺地立即把敏撲倒地上，用身體掩護她，同時拔出小刀，如子彈般飛快擲向日本鬼子，準確地刺中他的心臟。

這千鈞一髮的驚變，與死亡擦身而過，卻又同時夾雜著我和敏緊緊相依的奇妙感覺；種種思緒，令我一下子未能反應過來。

「謝天謝地，我殺了他！」我爬過去碰一碰他，確認他這回是真的死了。

然後，我爬回去告訴她：「現在沒有人威脅我們的安全了。」

當我預備發訊號給大腳、示意我們要回去時，「砰！砰！」兩聲倏地傳來，我不用看也知道，又有兩個小日本被莫射殺了。「謝謝你，莫，難怪人人都稱許你為『神射手』。」

之後，大腳便在貨倉門口向我發出安全訊號，而敏亦緊貼著我開始移動；這時候，我們已無需再用繩索了，可以一起移動。好不容易抵達了貨倉，我才如釋重負，高興地說：「我們安全了！」

沒想到敏竟然在哭泣。

「為甚麼哭？」我不解道。

「這是我一生最難忘的時刻。」

「何故如此難忘？」我問。

她滿臉通紅，羞道：「因為……因為剛才殺敵的情景。」

我又問道：「你需不需要先休息一下才去見指揮官？」卻見她搖首表示不用。

「那好，我們行動，」我回頭向她說：「你是否還需繩索引路？」她微窘道：「你……真討厭！」我兩肩微聳，只好說了句「不好意思」，她聽罷又略帶一絲甜蜜，輕道：「沒事！」

> **繩緣**
> 情來暗結一繩牽，
> 陌人岸上見鍾情。
> 繩緣初定甜在心，
> 災禍難分望光明。
> 甜蜜墮回憶，
> 命運怎能適？
> 戰地勇士披星月，
> 天涯愛侶浮人海。
> 人不見、哪處飛，
> 難解情鎖困心悲！

我領著她走到作戰指揮部。甫見謝團長，我便敬禮道：「報告！少尉昇完成任務，女童軍敏和國旗安全抵埗。」

團長表揚道：「幹得好！」然後便與敏握手道：「你真是勇妹，我們部隊以你為傲，上海市民亦以你為榮！」又續道：「四十多年前，大清國被日本打敗了，很多土地因而被小日本奪去了！這次，我們寸土必爭，定要打敗小日本！把他們驅趕出國，要他們葬身大海！」

團長的這一席話令我們很振奮，故我不禁提議道：「報告團長，我提議唱歌升旗，我來吹小號伴奏！」

團長說：「好！非常好！來吧！」

我從行裝袋中取出小號，長官則號令士兵列隊舉行升旗儀式。

長官大喊：「敬禮！」

我開始吹奏小號，長官再喊：「唱《勇妹》！」

> **勇妹**

　　勇妹
　　從天來的勇妹！
　　奇異來送旗
　　哼，侵略者必敗
　　狂吼聲震天
　　公義勝利屬我們
　　邪惡必自斃
　　衝鋒槍林彈雨下
　　你真是勇妹
　　國旗增強士氣
　　沒反悔、無憾
　　龐大力量壓敵人
　　國旗飛揚昇
　　國旗令戰士堅定
　　你真是勇妹
　　奇蹟有如天助
　　勇敢中國人！

當士兵們歌唱完畢，我便喊：「升旗開始！」然後士兵便把旗幟穩固地綁在竹枝上，舉行儀式；謝團長授旗給我，我接旗後便激昂地大力揮動國旗，在指揮部內緩跑，看到的軍官、士兵們全都振奮不已！

後來，團長命令我把旗幟展示在貨倉樓外，並囑咐道：「注意安全！」又續道：「當租界人民看見國旗，他們必定以奮力抗戰的我們為榮！」此話引起一陣掌聲。

他又對我道：「這是險地，你快把敏安全地送回租界。」

我望著敏，卻見她激動得熱淚盈眶。與謝團長和一眾官兵握手道別後，我靠近她說：「我們要抓緊時間返回租界。」

她不發一語，只是點頭同意。

雖知她不願離開，但亦不得不對她說：「我們起程吧！」

一路上沒有甚麼問題，直至我們到達蘇州河邊。正當我們準備由橋底爬上岸時，忽見兩名租界巡捕；我立即摀住敏的嘴巴，其中一名巡捕用手電筒往橋下照射，我別無他法，只得趕快潛入水中迴避。於是急忙低聲對她說：「你要吸一大口氣，然後憋著隨我潛進水中避開搜索。」

她慌忙中看了我一眼，卻沒有絲毫不安，竟透出一絲冷靜。此刻，我已明白她把生命毫無保留的託付於我，我更不能辜負她對我的信心。

於是我們小心翼翼，半游半潛的避開巡捕的搜索；當我們浮出水面時，他們已經離開了。

只見敏一臉蒼白，顯然已消耗了不少體力，於是我對她說：「我揹你回去，找你弟弟，好嗎？」她點頭應允。

我又問：「你冷嗎？」

她輕輕的答道：「我不冷……」

我想，或許她只是不想給我太多麻煩。之後，我便背著她急步往匯中飯店走去，到了飯店外圍，便看見聰欲哭的模樣；他很快看見了敏，

似乎感覺到他姐姐有些不適。

我說：「娃娃，沒啥大事，我們曾經潛水避開巡捕，她可能是著涼了吧。」

幸好敏很快便恢復了體力，站起來向我道謝。

我輕輕靠近她身邊，問：「我與你何時可以再見？」

她說：「如果你相信我們真的有緣，你可以來震旦女子文理學院找我。」說罷，聰便把他的外套披在敏身上，讓她保暖。

我想著，報館很快便會報導女童軍送國旗前往四行倉庫守軍的消息，振奮我軍士氣！希望藉此機會向全世界轉達中國軍民心聲，誓死抵抗日本軍國主義侵略！但是，我可以肯定的說，沒有新聞會報導這段期間發生了一個可歌可泣的愛情故事——兩人戰地初遇，愛情萌芽於一條彼此牽引的小小繩索間；二人生死與共，恍如前世註定的情緣！

> **前世情人**
> 前生愛已定
> 小繩作紅娘
> 戰火愛河裡
> 賺人淚無常

我顧慮她的安全，心中雖然不捨，卻只能無奈地催促她：「趕快離開！」

視野中，她的身影漸漸遠去，消逝於無形，揮動的手亦在空中消失了。但是，她的音容笑貌、繚繞的香氣，將長存我的腦海中，永不磨滅。敏是我的夢中仙，這段往事非常浪漫，教人回味，卻又似利刃，時常刺得我的心隱隱作痛。

翌日，穿越炮火冒死送國旗的新聞令舉世震驚，各地記者紛紛拍電回國報導。但不幸的是，一九三七年十一月十二日，上海亦終淪陷於日軍魔爪之中。

大戰之後

戰爭繼續著，雙方傷亡慘重，我軍的損傷卻更嚴重——折兵逾半，軍火、彈藥逐漸殆盡。

在奉命死守四行倉庫的第六天，老爹蜷伏在地，靠近我，然後用低沉嚴肅的聲音透露道：「昇，我們快不行了，不能隨大隊退守南京，因為我們這個連隊奉命原地解散！我來問你，你能否盡忠職守，報效黨國恩情？」他續說：「你知道這是多麼嚴肅、重要的問題嗎？」

我毫不猶疑，直截了當地答道：「我明白我的任務，作為士兵，我會盡一切努力為黨國戰鬥，置生死於度外！除此之外，我根本不知自己還能幹甚麼……」

他對我的回答很滿意，雖然語調改變了，但仍保持他的說話風格。他開宗明義告訴我一個計劃：「我要你在上海幹地下工作。開始時，你會是獨立運作，沒有人幫你，也不能依靠朋友，因為你很難辨別出誰是人、誰是鬼。所以，你要把所有人都當成是鬼！我是你唯一的聯絡人，如果我死了，你就自由了；但你亦終將失去身分，因為沒有人知道你是為黨國工作。」

我不知如何應對，唯有點頭稱是，我想，他會帶給我一個驚天任務。

他好像怕我懵然不知事關重大，續說：「你不會有退休金、長俸，你的記錄可能會消失，你是否還要幹這個活？」

他這麼回答反令我更為堅決：「老爹，我自幼父母皆亡，孤身一人在世上；如果沒有你，今天都不知在幹啥。在我心中，早就認了你是親爹，我這條命是你撿回來的，你要我幹啥，我就幹啥！不用多說話！」

「好小子，我知道你可以勝任，這兒有點小錢，你拿去。當你認為安全時，儘快找份工作，去十六鋪碼頭那兒找，這樣你就會有工作證用作身分證明。最好是修船的技工或碼頭技術員，這一類工作比較適合你。」

所以你每天都要去看一看告示板有啥活幹，如果我去找你，我便會在告示板上貼上『有人需要修理白帆船』，亦會用軍隊密碼加密。如果你還未懂摩斯密碼，就得趕快學，那不太難。」

「真巧，老爹，我懂摩斯密碼，不過要溫習一下。」

「你不能帶著莫給你的密林手槍到處跑，那太危險了，租界巡捕、日本兵都會抓你。但你又不要把它扔掉，應小心藏起來，誰知道會不會有用得著的一天？現在趕快換衣服，尋找退路，不要向任何人道別。」

他又説：「事實上，每個人都跑了！但千萬不要讓別人知道你去哪兒，或者幹啥子。走吧！謹記你的出身，你是農家子，出生後就被遺棄了；如果有巡捕問你幹啥活兒，就説在十六鋪幹活。那兒人來人往，他們未必知道誰是誰，其他就靠你自己隨機應變啦。」

老爹説罷便輕輕推我走，又拍拍我的肩膀説：「注意安全，我很快就會來找你！」

打完仗，上海還未完全回復太平，市內魚龍混雜、一片混亂，謠言滿天飛，亦真亦假。就好像有人想把上海捲入混濁的風眼裡，趁機混水摸魚；而租界政府和日本佔領軍亦是關係微妙，日軍早就和外國政府簽訂緩和約定，製造條件進駐租界。最終，日本軍控制上海東、北區域，涵蓋虹口；而英國人仍管有黃埔區，法國人則是徐匯區。外間流傳，日軍將會大舉進攻英、美、法在東南亞的殖民地，戰火很快便會蔓延至星加坡、馬來亞、香港、菲律賓等地。一切便如火上加油，愈燒愈烈，而日本軍國主義亦愈來愈肆無忌憚，既無恥，又赤裸裸地侵略世界各地。

淞滬戰役令國際形勢突變，中國聯軍損兵折將達二十多萬，日軍亦喪失了四萬多兵力。這個結果，完全説明了日本軍國主義的侵略是何等無恥，鬼子天性殘酷、大開殺戒，多達五十萬中國軍民因戰禍而傷殘，國軍亦因拼死抵抗日軍侵華的攻勢，付出了沉重代價。

交戰期間，閘北和虹口區成為前線戰區，國軍精銳部隊歷經連場大戰，損失慘重；有些部隊更在交戰不足三小時後，已犧牲了三分之二的士兵。守衛四行倉庫的部隊因為靠近租界，肩負特別任務，所以沒有其他戰線那麼傷亡慘重。在國際政治方面，西方領袖看見中國軍民咬緊牙關、誓死抗戰的精神，改變了戰前對中國抗戰能力和決心的看法，在此役之前，他們普遍認為日軍可一舉吞佔中國土地，簡直是探囊取物、唾手可得。

　　然而，淞滬戰役後，日本軍政界驚覺現實完全不是那麼一回事。戰役期間，泯滅良心的日軍殺害不少中國平民，殘暴不堪、絕不手軟；在淪陷區，日軍任意虐待、強姦婦女，強加莫須有的刑罰，刻意製造饑餓、拉夫、掠奪財產、無情殺戮，無所不用其極。最終，國軍被迫棄守上海，退往西面戰線重整軍力，保衛首都南京；很不幸，因為沒有足夠彈藥，在一九三七年十一月十三日，國軍再度被迫棄守昆山，撤退至吳福、錫澄國防線。

　　歷經整整一個月的戰鬥，南京因無空中保護，遭受無情炮火轟炸，戰況慘烈非常；終在一九三七年十二月十三日，南京被全無血性、暴虐無道的日軍攻陷。當時正值寒冬，被日軍包圍的國軍，能逃離封鎖線的機會渺茫；結果，多逾十萬士兵被俘虜和處以極刑。日本在中國人民身上犯下的暴行，可說是血債纍纍；而南京大屠殺更是毋庸置疑的戰爭罪行！更可悲的是，這僅僅是侵略者惡行之始，戰爭最終延續了八年才結束，那時中國才能收復失地、挽回榮譽。

　　觀之上海，整個閘北區差不多盡成廢墟，虹口區、楊樹浦、吳淞等損毀亦高達七成，很多地方無法辨認。四十多萬難民從損毀的家園走難到公共租界謀生，於是我乘勢夾雜人潮之中，往租界逃難。倒沒想到，租界內仍能維持一派繁華景象，與界外境況比較，真是天堂與地獄之別。

　　一九三七年十二月五日，日本侵略軍成立傀儡政府，名為「上海市大道政府」，在浦東設立行政中心。所以，我必須儘快在上海找到工作，掩飾身分，避免招人懷疑。

有一天，我琢磨著如果可以當上黃包車伕，倒方便我在城內各區走動，也有時間思量下一步的計劃。閒時，我便跑去十六鋪碼頭找工作和查看告示板，可惜，仍沒有任何留給我的訊息；我又去過黃包車館找工作，卻同樣徒勞無功。失望之餘，我亦必須時刻保持警覺，迴避附近的巡捕和日本特務。

一九三八年仲夏某天，當我再去黃包車館找尋工作時，事情終有轉機。那天，當我依舊不知如何是好時，突然聽到有人喊我的別名，回頭一看，只見從前的戰友向我跑來；我立刻反應過來，把帽子拉下遮住面容，嘗試避開他。但這些小動作還是沒能阻止他，他跑過來問道：「你幹嘛避開我？不念舊情嗎？」

當下，我顯得極為侷促不安，只好別過頭，低聲道：「哪兒的話，我只擔心巡捕和特務，他們在追捕前國軍⋯⋯」

他聽到我這麼說，面色凝重，打手勢著我跟他走。於是我若無其事地隨他一起走，走到另一邊的麵檔前才停下來。我叫了碗陽春麵，像餓鬼般狼吞虎嚥，滿嘴湯汁，吃相非常難看。

我們垂首寒暄一番，他徐徐道出心中憂慮：「昇，不論甚麼情況，在任何人面前都要切忌提及國軍。如果他們知道，就會拘禁你，甚至把你交給日本憲兵部特高科處置，這鬼子總部就設在四川路。」

我對「日本憲兵」這字眼反應敏銳，立即警惕起來，含糊地說：「日本憲兵？」

只聽昔日同袍加重語氣，清晰地吐出激憤之情：「那鬼地方，人站著進去，放在袋內，橫著出來！」

我結結巴巴地問：「放入袋內？」

「傻子，死屍袋！」

「啊！」這句話令我乍冷乍熱，頭皮發麻，一陣涼氣從腳趾頭竄上腦子裡。

他續説：「不要告訴任何人，你絕對要保守你的身分秘密。」

我點頭同意他的説法，他又問道：「你在上海有啥工作？」

我説：「自解散後，在上海無親無故，還沒找到份工作過日子。」

直到這時，我才發覺他一身黃包車伕裝束，「你呢？咦，看你的制服……哈！『二三九』，我想你是黃包車伕，對嗎？」

「怎麼啦？我也要幹活啊！」他稍微停頓又説：「不過我比較幸運點，解散後巧遇小學同學，他不知道我當過兵的底細，於是介紹我幹這個活。不過，最近他沒幹了，回老家去了。」

「我想……可能有機會給你一份工作！」於是他便催促我道：「你趕快吃完，我們跑過去看看！」

我非常激動，很想儘快找到活幹。當我們到達黃包車館時，他把我介紹給管事，説：「咱倆是同學！」又為我説了很多好話。

知道我在找活幹後，管事便抬頭看我，從頭到腳打量一遍，説：「你看起來挺結實的，不過你得把三成收入分給我，捨得嗎？」

當我剛要開口説話時，舊同袍卻高興地代答道：「那當然了，一個子兒也不會少！」他又按了按我的頭，説：「小子，快點磕頭感謝！」

當我想著是不是要跪地、向他磕頭道謝時，幸好管事滿意，沒讓我那麼做：「不用，只要聰明點，帶眼識人就行了。」

「知道了！」我裝作誠懇答道。

他表示滿意，然後又奸笑道：「今天有啥好活兒？」

友人立即從口袋中掏出幾塊錢給他，説：「小小意思，不成敬意。抱歉這些不夠你買包香煙，只是聊表心意。」他又轉過頭來對我説道：「將來我們多幹些活兒，就多些錢孝敬大哥。」

他的馬屁，管事聽得很是順耳，也就不找我麻煩，從抽屜內拿出份表格來，叫我把姓名、年齡、籍貫等填了。

當我填完後，他便拿起印章，望著我嚷嚷道：「今天算你走運，老子心情好！」砰的一聲，只見他提高印章過肩，大力蓋上後又道：「你現在是黃包車伕『四五四』號，跟祥去領制服和車子，今天開始幹活了！祥，你教他一些規矩，去吧！」

我恭恭敬敬地向他鞠躬謝道：「真感謝你，我會好好做的。」

離開黃包車館時，一路上只覺得能找到幹活，令我如釋重負；我感激地望著祥，他亦沉重地說：「你知道，我們這種人很難找到幹活，車伕證就是我們最重要的身分證明。」

他說出不為人道的辛酸時，一直緊盯著我；雖然我很想回答他，可是滿臉緊繃著，只能定睛望著他，不能發出一聲，已經淚盈滿眶了！

他拍拍我肩膀，寬慰道：「從今開始，往事如煙，重過新生吧！」

接下來，他向我細述收費、主要區域、大街小巷、景點、餐廳、歌舞廳等，說了一大輪後稍稍停頓，又吞吞吐吐地道：「除非……你有客人要送或者有人預約要車，否則，不要在北四川路躊躇！」

「為啥？」我想他可能在警告我。

「那裡是是非之地，生人勿近，爾虞我詐，有大量特務、秘密警察集中在那兒。如果他們懷疑你是國民黨或者共產黨，他們就會找你麻煩，立即逮捕你！」他續說：「不要掉以輕心，不去也罷！」

「我曉得！」

重大任務

又是天清氣爽的一天，我一早便跑去十六鋪，看看老爹有否留下消息；其實，我差不多每天都會跑一趟。十六鋪在黃浦江口，清朝年間興建使用，原本計劃建造二十七個碼頭，不知何故，只建了十六個碼頭就沒再動工了；十六鋪是其中最大的、亦是最繁忙的客貨運碼頭。

尋找消息時，我發現了告示板上一個不明顯的位置，貼著一張「白帆船需要修理服務」的字條，我立即明白那是老爹的聯絡方式！真開心，原來他真的沒有忘記！我心中雖然興奮，但表面上仍要不慌不忙，然後趁沒人注意時拿走字條，若無其事地離開。我拉著車在一處安靜地方坐下來後，用密碼核對解讀，上面寫著：明天早上七時，城隍廟見。

這幾天心情挺好，先是重遇敏，然後又收到老爹的消息，兩件事都令我精神亢奮；此刻只希望星期天快些到來，因為終於可以與敏相會！

翌日清晨五時左右，我就起床預備去城隍廟。我搭住的是一間板房，房東是個寡婦，年約五十歲，我叫她王大媽。王大媽說她的丈夫是幹穿州過省走貨買賣，賺些蠅頭小利。不幸在兩年前，遇著國軍與小日本交戰，被日本鬼子打死了；禍不單行的是，就連她的獨子也不知所終，她想他可能是去參軍了，但又不知道是哪個部隊。不過，她說只要兒子參軍對抗日本鬼子的話，管他是國軍還是八路軍，她都不在乎。

王大媽見我起來了，便問道：「昇，你要不要煮飯，還是饅頭？吃完有力氣才去上班啊。」

「不用了，這麼早就麻煩你。」

「沒事，給我十來分鐘就行了。」

「那好吧，我去洗把面就來，謝謝。」

王大媽就像我娘，總把我當兒子看。平日裡我們無所不談，包括她的苦難，她的婚姻；她很照顧我，令身為孤兒的我像有了家人似的，希望有一天，我能報答她的恩情。

洗完臉後，我便走出房間幫她準備早點，她叮囑我說：「你要注意安全，現在上海不太平，情況較任何時期都複雜得多。」

我點頭表示明白。

她續說：「日本侵略軍和偽政府在租界的勢力越來越大，我們生活更加困難了。不僅如此，上海黑幫分成不同黨派，一些幫小日本，一些支持國民黨，又有一些是共產黨的。」

「我恨那些叛國賊！」我難掩恨意地應道。

「噓！你不可以這麼公開說，小心隔牆有耳！」

我說：「嗯，我會小心的，除了你之外，不會隨便表露心聲。」

「淞滬戰役後，日本侵略軍向南京進發，國軍又打不過他們；於是南京失守了，造成三十多萬人被屠殺的慘案……我家南京親戚也被殺害，他們真不是人，簡直是魔鬼！」

聽到她這麼說，又刺痛了我的「舊患」，想起過往更是心如刀割：「王大媽，我是孤兒，父母雙亡，很多人都像我這樣家庭破碎……」

正巧，牆上掛鐘打響報時，提醒我已是該出門的時間。

我對她說：「我要走啦，有空再聊。」

王大媽點頭，然後給我開門，說：「注意安全，今晚會回來吃飯嗎？」

「不，今天會很忙。」

城隍廟是上海黃浦區著名景點，建於一六四七年，素來香火鼎盛，大家都去祈福求願；不論大小事情，都會誠心上香拜神，問吉凶、問姻緣、求財富、求安康等。他們信奉道教，相信宇宙由「氣」所生，氣清輕者升為天，反之則降為地；而天亦各有管治者，最高是為三清，而「城隍」則是管治城池的天官；他們認為如果以誠打動城隍，所有問題都可以迎刃而解。

約莫六時半我便到達城隍廟，已有很多善眾在廟內上香；城隍廟說大不大，說小不小，佔地約五十畝。我在大門外一邊躕躂，一邊細心留意出入的人，希望看見老爹。

沒多久，遠處有一個人，手持雨傘慢慢地朝我走來，說：「你知道怎樣去天堂嗎？」

這樣的問題聽起來怪怪的，但也許暗示了某些玄機，而且我亦好奇持傘人的樣子。

他接著說道：「天堂有路你不走，地獄無門闖進來！」我猛然醒覺，這是老爹的聲音！

當老爹把雨傘收起來時，我終於再一次見到他；可是我要壓抑著興奮的情緒，安定下來；老爹示意我跟著他走，當我們走到廟內祭壇前，便像其他善眾般跪下、上香、向神明祈福，趁機看看有沒有尾巴吊在後頭。

老爹打量四周數遍後，說：「小子，應該沒有尾巴。你知不知道上海的情況有多壞？國軍的上海站最近給日本鬼子和偽軍端了！今天我給你兩個任務：一，你要用盡方法暗殺大漢奸、偽政府要員；此人名為唐紹儀，為人狡猾，警覺性極高，有精良的保衛隊時刻護著。不過，話雖如此，每個人都有弱點，我們可以充分利用。」

我問：「甚麼弱點？」話音剛落，便看見有位婦人走近，打斷了我們的對話；老爹打了個眼色，著我一起離開廟堂。

走在廟外，老爹續道：「唐紹儀喜歡古董，可以說是行家，有很多收藏品。他住在徐匯區，你得儘快幹掉他。」稍頓，又說：「第二個任務是去尋找兩噸黃金。」

我驚道：「兩噸黃金？」

老爹說：「對，兩噸，絕不會少！當國府知道上海戰場不利時，決定搬走貴重資源，其中黃金是首要處理的。」他刻意用凝重的眼神盯了我一會兒，以表示這件事有多重要。

他接著續道：「國軍前往中國銀行上海分行提取黃金和負責押送搬運。押運隊有十名全副武裝的士兵和兩輛貨車，指揮這押運隊的是上尉王福和上士陸峰協助，黃金和押運隊全消失得無影無蹤了。」

「他們去哪兒了？」這麼多黃金不見了，真是匪夷所思！

老爹應道：「小日本和偽政府也收到搬運黃金的風聲，所以他們也正在找尋黃金的下落。據我瞭解，他們還未找到。」

「這是校長下的命令，再由戴老闆指派給你。」老爹下一句吐出的話令我受寵若驚。

「校長？你說是黃埔軍校校長，蔣委員長？」我的聲帶發出不協調的嗓音，渾不如平日的從容，暴露了我此刻略帶緊張的心情。

「對！」他簡單直接地回答我後，便把話題轉回任務上。

我真的很難相信，原來軍統局最高負責人知道我的存在，可是老爹卻示意我不要多問；然後他拿出兩張照片，分別是上尉和上士，說道：「你有一枝密林手槍，我會多給你一枝有滅聲器的手槍，就放在後門門神附近的樹盆下。我離開後，你自個兒去拿來用，我還放了些錢和小黃魚給你用；如果你想見我，在同一地方放下紙條，記得要加密處理。如果我有事要找你，也是這麼安排。」

我們差不多談完了，他說：「嘿，小伙子，我差點兒忘了告訴你一件要事。」

「還有其他事兒要辦嗎？」

「這兩件事都夠你忙了，你要在一個月內殺掉唐紹儀。第二件事，你倒有多些時間處理，但亦希望三兩個月內有些眉目。上頭說要給你鼓勵，找到黃金後，你可以留點作情報運作經費，高興嗎？」

「高興！是否只有這些事情呢？」

他嚴肅地道：「好啦，我記性可沒那麼不濟！對了，你已獲升級為軍統局中尉了。」

「中尉？」

「對，中尉。」

「不過，我現在不能給你委任狀，但我向你保證，當你完成這兩項任務，我一定辦好給你。我要走啦，如果沒啥事兒，兩星期後在此再見。」

當他正要離開時，我問道：「可否給我這兩人的照片呢？」

「我只能給你多看一次，慢慢仔細看，記下他們的特徵；你不能留著照片，那樣太危險了，若給日軍和偽軍查到就麻煩了。能記多少是多少，他們出現在你面前時未必就是照片中的模樣，所以你要用直覺推斷，分析他們的身分……好了，不多説了，下次再見。」

他和我握手後便匆匆離開，沒有回頭看我。

當天晚上，我如常在百樂門外接生意。我等來了一位穿著華麗的男客，要我拉他去法租界徐匯區的高級住宅區；他看起來喝了不少，坐下沒多久就打呼睡著了。距離目的地大約還有兩條馬路時，我發覺有輛轎車已經緊跟著我走了一段路，忽然間它更猛然超前；我倒沒覺得甚麼事兒，自然地把車靠路旁停著，方便它駛過去。但是，它卻沒有離去，反在不遠處停下來。

我嘗試拉車繞過它，卻見三人從車上走下來；其中一個揮著鐵斧，凶神惡煞地衝過來，我本能反應的立即應對襲擊。我放下拉車桿作為後盾助力，蹲下身子、紮穩馬步；在迅雷不及掩耳之際，用手壓著拉車桿立即飛腿踢出，一擊即中，把他彈開五、六呎遠，伏在地上，動彈不得。其他兩人被我的反擊嚇得目瞪口呆，就在他們愣住了的瞬間，足以給我時間從拉車桿中拉出長約兩呎的單節棍。車上的乘客被我的不尋常舉動弄醒了，我小心翼翼把車放在安全的位置，不讓他受到襲擊波及。

另一人執起斧頭再次攻擊我，他雙手交替握斧，行動飄忽，幾番轉動身軀，時左時右，企圖擾亂我的視線。當他捕捉到有利攻擊的時機時，快速地舉起斧頭向我當頭劈下，意欲一招取我性命。就在我險些被劈中時，眨眼間速移至他的背後，用木棍往他背部連環抽打；我毫不留手地

打了好一會兒才罷休，只見他頭暈目眩，卻又很快恢復精力。一見有機可乘，他不再理會我，轉移攻擊我載的那位男客，舉高利斧直衝黃包車，眼看就要劈下。情況危急，我立即跨前一步，揮動木棍格開了那一斧的攻勢，令它失了準頭。與此同時，我蹲穩馬步迅速轉身，大喝一聲：「嘿！」說時遲、那時快，一腳如箭踢向他的手肘，一時不察的他頓時向後倒，利斧亦順勢脫手。我連忙乘勢使出連環拳，只見受到重創的他血流披面，砰然倒在路上，無力呻吟。

第三個同黨見此情況，已嚇得屁滾尿流，只恨娘親沒給他多生兩條腿；當下跌跌碰碰的扶起兩位難兄難弟，連忙開車逃掉了，像夾著尾巴的喪家犬，吃不完，兜著走！

這場險象環生的惡鬥不消數分鐘便解決了，四周恢復平靜，好像沒事兒發生過一樣。本來通身酒氣的男客也驚得醒過來了，喘息道：「小、小伙子⋯⋯不、不用送我回家了！」

我收好木棍在拉車桿，定下來問道：「你想去哪兒？」

「我們得趕快離開這兒，那些流氓一定會捲土重來，置我於死地！這回還好有你，救了我一命！」他接著告訴我要往哪兒，我還在嘀咕著究竟發生何事，思量著施襲者應是上海黑幫的手下。若是如此，那便代表這位乘客同是江湖中人，所以他的仇家才會錯認我與他是一丘之貉。

可我沒時間多想，很快就到達目的地法租界盧灣區步高里，那兒是著名會館地區；只見五六名身穿唐裝的彪形大漢站在館前，那是這些幫派小混混的裝束，一看見我們，便齊聲大喊：「四爺！」

「四爺？」我望著他，思量著這位貴客的身分，心想這位「四爺」不會就是鼎鼎大名的「上海灘之虎」吧？

天啊！我竟無緣無故被捲入上海黑幫的漩渦裡。我連忙想法子脫身，只想早走早著，哪管能不能拿回車資！其實，他們這夥人本就不會給我車資，像偽政府那些混蛋官員一般。可是，「四爺」見我要走，立刻便揮手阻止我離開，還質問道：「小兄弟，為甚麼急著要走？」

「你的大名令我發抖，大爺。」我坦言道。

他聞言大笑，很是受用，得意道：「沒錯，我的名字確實令許多人失魂喪膽，但小兄弟，我可沒瞎，你絕對不是其中之一！」

他的手下聽罷朝我看過來，應聲附和道：「是、是，四爺！」

四爺又道：「你們可不要小瞧他！大概半小時前，他赤手空拳打退三名持斧襲擊我的斧頭幫流氓，更重創其中兩個，嚇得他們如過街老鼠般，一下子跑得無影無蹤了！」說罷又指著我向嘍囉說：「這樣的他會怕我嗎？」

他拍拍我的肩頭，說：「跟著我來聊一聊，多給你些車資，走吧！」

我跟著他進入會館，那是傳統的上海大宅，具西洋風格；大廳橫樑上掛著「忠義堂」牌匾，廳中央擺放了一套精緻的酸枝座椅，左右各擺了兩套座椅配茶几，大概可同時容納十數人聚會。幫會規矩是主人居中，重要人物和貴客分坐兩翼，以風水格局來說，左青龍、右白虎，形成三角，正是一個戰鬥格局。

只見大廳內有一位神態飛揚的中年男子坐在中央，一名男子和一名少女站在其左側身後。那少女約莫十八歲的年紀，桃腮杏臉，唇紅齒白；一雙美目水汪汪的，睫毛又長又翹，長眉入鬢，端的是美貌驚人。

四爺請我在右邊坐下，我禮貌地道：「我站著就可以了。」

我低頭看了看身上的車伕制服，上面還標記著「四五四」；放在這場合，確實挺滑稽的。站在主人家身後的兩位年青男女，神色傲慢，看我不爽；四爺沒有放我乾站著，反用加重語氣要我坐在他身旁。很快有人給我送上香茶，居中的大爺便招呼大家喝茶；我腰板坐得筆直，目不斜視，輕輕地呷了口茶。

大爺開口說道：「四弟，聽聞你今天被人伏擊，看來是斧頭幫那班混蛋所為！這位小兄弟救了你一命，是吧？」

四爺回答說：「大哥，我只是多喝了兩杯，醉了才沒有防備，沒想到這幫流氓竟趁機發難！要不然，再多來幾個來我也不怕，哪用得著甚麼幫手！」

大爺又轉過來間我：「小兄弟姓甚名誰啊？」

「我名陳昇，大夥都叫我『昇』。」

「你為何給我老弟解圍？」

「本以為那三人是來找我麻煩，我可沒想過要幫他。只是眼看他們就要用斧頭劈下來，迫不得已才出手，哪有選擇？」

大爺說：「看你身手不錯，習的是哪家武術？」

「虎鶴雙形。」

「哦，那是南少林的馳名拳術，還有其他嗎？」看起來，他也是行家。

「我也練過劍術、刀法。」

「那你精通甚麼武器？」

「身為黃包車伕，不用打架。我只在工餘時間練習『花頭繩棒』。」

「『花頭繩棒』？恕我孤陋寡聞，未曾聽過，你可否給我看一看？」

我站起來，從腰間抽出那根所謂「花頭繩棒」，恭敬地雙手高舉，遞給他看。那根木棒子長約九吋，棒的一頭接上繩子，繩子的另一頭又紮了一個結實的花繩球。

大爺拿在手中翻來覆去，邊看邊說：「這不算甚麼武器，只是一根小棒子和一根繩子，拉車時又可以用來固定行李，倒也不錯！」

「是的，有時我也會這樣用的。」

大家聽到我的回答後都笑起來，只是那名少女卻依然木無表情，愛理不理。

她忽然走上前，臭著臉道：「爹，可否讓我看看？」

「拿去。」大爺說。

她態度輕蔑，隨手鼓搗著看，更刻薄地道：「垃圾！」然後隨手把它拋向空中。

雖然我不想再顯露身手，但她的無禮卻在我心頭上添了把火；我再也沉不住氣，立即從座位跳起，一個鯉躍龍門便飛快地往大廳中央奔去，在「花頭繩棒」差不多落地時接到手中。

　　我真的難以忍受她的臭脾氣，接過繩棒後便抱拳向在座各位行禮告別。大爺見狀馬上打圓場說：「小伙子，看你剛才的表現，真是身手不凡，你可再露兩手給我們觀賞嗎？」

　　我說：「天外有天，人外有人。我陳昇只是個無名小輩，謝過各位爺們的賞識了。車費就算了吧，就此告別。」

　　當我正想離開時，那少女卻從旁跳出來，把我攔住說：「你的脾氣倒也不小啊！自恃武功高強，目中無人！竟然給臉不要臉，敢不敢和我切磋切磋！」又道：「你以為這是甚麼地方，可以自出自入？這兒可不是給人串串散步的，這是龍潭虎穴，容不得你來撒野！從沒人敢說來便來，說走就走！」

　　四爺見形勢不妙，忙幫我解圍道：「小丫頭，是你無禮在先，羞辱對我有恩的小兄弟，又隨意對待他的東西，這是你不對！」

　　她望著父親，又瞄了一下堂上，只見大家木無表情，心知形勢不妙，連忙轉個態度，對眾人說：「好，各位叔叔，是我不對。但我還是認為他的本事的確不及我，我想向他領教幾招！」

　　她這麼說話，把氣氛弄得很僵，四爺不得不站起來向大家說：「他是我的朋友，希望大家給點面子。」

　　話未說完，卻見少女轉過身來衝著我說：「你敢與我過幾招嗎？」

　　我說：「小姑娘，我早就說過『人外有人』，我不過是一介莽夫，習武只是為了強身健體而已。」

　　「廢話少說！接招！」她二話不說，站了個馬步，雙手高舉，輕輕揮動，像蝴蝶般在空中飛舞。

　　「你習的是蝴蝶掌嗎？」我問道。

　　「是又怎樣？」她繼續態度輕佻，我再難沉得住氣！

「我也習過蝴蝶掌一招半式，如果你能碰到我的上衣，就算你贏！」

「我才不用你讓！你必須動真格，全力進攻吧！」她很不服氣地道。

話音剛落，她的身軀便不斷旋轉，翻動掌式，看來當真是想一掌把我修理得貼貼服服。

只是我早就看穿她的戰略，心中已有應對之法，當即靈活地左右移動，利用肩膀閃避、借力，四兩撥千斤的把她的攻勢卸於無形。接著，我一個急俯身，再一腳橫掃千軍，又倏忽站起來……這些連環招數，總是出其不意地擊中她的肩膀。終於，她不小心受了我一掌，直退了三四步才停下。

她的眼珠上下轉動，彷彿想打鬼主意轉守為攻。突然，她變了個花式，只用單腳站著，抬高另一隻腳，擺出不同花式；雖看似沒甚章法，實想擾亂視線，令我分心，瞧她擺出這些古靈精怪的招式，真不知該笑不該笑。

我想，她下一招數應是來自站立的腿，所以才會如此狡獪地不斷舞動，像潮水般湧上湧落；她打算令我墮入她的圈套，因為她知道我曾習蝴蝶掌，才會用這些怪招來蒙我。

只見她擺好金雞獨立的陣勢，那高懸空中的腿打了個圈兒，然後又突然收起，瞬間伏低身子，迅速滾動；一下子便欺至我的腳下，然後伸出雙手，打算像蟹螯般牽制住我的雙足，令我失衡倒地。

可惜，那算是甚麼招數呢？在我面前，她的如意算盤可打不響！當她的身影差點兒到我身邊時，我連忙來個後空翻，可她的反應倒也機靈，立即改個招式，打了個前空翻追我，令我退無可退。我唯有晃了個虛招護住胸口，緊接著再打出一掌把她擊退，既能抵消她的衝擊，亦可後發先至的還擊。

我退後一步，抱拳對她說：「小姑娘，今天到此為止，好嗎？」

只聽她父親開懷大笑，說：「小雅，這小兄弟已對你手下留情了。他的右手原可攻擊你的頭部，兩隻手指又可隨時彈出來，直插敵手雙目。若他真的這樣，你就變成瞎眼蝴蝶啦，哈哈！」

我看見她貌狀甚怒，對父親的話置若罔聞，還立即跑去武器架子前，一手拿起一枝紅纓槍，緊握在手指著我說：「喂！你過來！別再讓我，只管放馬過來！拿起你的廢物繩棒，我真想領教領教它有多厲害！」

當我聽到她說我心愛的繩棒是廢物時，痛似萬箭穿心，這繩子是敏與我的定情信物。我拿棒在手，眼睛緊緊盯著她，只見她神色冰冷，身上一襲刺繡華貴的絲質短打，腳踏一雙繡花的軟布鞋，恰似一尊俠骨神女的雕像，行動卻如豹一般傲視闊步，形態嬌美，我雖厭惡她的無禮，也不得不承認她確實有奪人的魅力。

她轉動那纓槍，細心的瞄準我，接著一邊轉動它，一邊快如箭般衝刺過來。我不敢輕視這猛然一擊，只能驚險地一個閃身，恰恰避過。我再也不敢怠慢，立即拉出繩棒緊握在手，嚴陣以待；當她再持纓槍刺過來時，我的繩棒已像飛龍一般追逐獵物。當它與纓槍相接時，很快便在纓槍上繞了數圈，我毫不費勁便把纓槍奪在手中！

我輕輕把它放在地上，說：「多有冒犯，還望見諒！我們別再鬥下去了，免得傷了和氣，好嗎？」

她經此一敗，頓時滿臉通紅，不發一言便走回父親身旁。我感覺到她正用好奇的目光來睨著我，當我們視線碰上時，她竟一臉害羞，把頭斜倚父親的肩上。卻見她的父親率先大力鼓掌，其他人亦跟著鼓掌；前一刻還是劍拔弩張的氣氛，霎時間變得融洽熱鬧。

大爺讚道：「小兄弟的武功當真超凡！怪不得他那麼容易就能擊退斧頭幫的偷襲。」然後還邀請我坐在他的身旁，我退卻道：「晚輩豈敢無禮！我還是坐回原位吧！」

大爺又對四爺說：「四弟，我們該拿他怎樣辦呢？」

四爺說：「我想收他為門生。」

大爺轉過來看我，我抱拳應道：「多謝貴人厚愛！我原是一個孤兒，在上海孑然一身，四爺願意關照我，著實再好不過；只是我習慣了自由自在過活，還是當一個黃包車伕最合我意。」

四爺說：「你今天與斧頭幫為敵，總有一天，他們必會尋仇。」

「我只是一個無名小卒，他們用不著來幹掉我；在上海，我只是區區螻蟻，如果他們真來尋仇，恐成笑柄啊！」說到這裡，我站起來再次向他們告辭，謝道：「非常感謝各位老爺的熱情款待，我要回去幹活了。」

四爺見我去意堅決，亦只好作罷：「好！小兄弟，你果真是條漢子！我說過，你已經是我的兄弟，在上海，無論你有甚麼麻煩，儘管來找我！我定必義無反顧，出手相助！」

說罷，他順手拿了些錢給我，可被我微微推開了手，說：「我不能拿那麼多錢，只收車費便可。」

他卻拉長臉說：「全部拿去！否則，你就不要認我這個兄弟！」

我無話可說，只好伸手接過：「那就恭敬不如從命，謝謝！」

大爺再次站起來，說：「今天我們有緣認識這位小兄弟，他不單武術超凡，亦有高尚品格，大家來敬他一杯！」

話音剛落，傭人已經上前給我們送酒。大爺舉杯向大家說：「我們為新兄弟，昇，乾杯！」

當我一口吞下杯中酒後，早些時候的「手下敗將」把酒端來我的面前，若無其事說道：「昇，請原諒小雅的無知冒犯，是我不自量力，我做錯。容許小雅借這一杯酒，向你道歉。」

原來少女閨名小雅，只是她忽然敬酒，的確令我受寵若驚：「沒事！謝……謝謝你！」

此時，傭人又給我們添酒，我緊握酒杯，不敢暢飲，只是淺嚐，心中卻對她突然改變的態度，既感錯愕，又好像撥開雲霧見青天，不由得振奮起來。只見她亦是淺嚐輒止，水汪汪的妙目還偷看了我一下；這不經意的少女情懷，著實令我手足無措，遐想不已。

此刻，心中暢快的我忍不住把酒喝盡，開懷地說：「今天有幸與你相識，也是一場美事。」接著又再三抱拳向眾人道別：「諸位，後會有期！」

他們親自送我出會館大門，依依不捨地揮手道別。

綁架

　　我換了套運動裝，以便舒適地騎自行車；晚上六時正，我準時到達敏家，已見她站在大門口等我。她穿了一套灰色的運動衣，纏上圍巾，戴著蘇格蘭帽，模樣可真是太美啦。

　　我揮手向她打招呼說：「你今晚很美麗呀！」

　　她微笑著沒有給我回答。過了不久，我騎著自行車靠近她說：「我們不要一起騎車到學校去，我遠遠的跟著你走。」

　　她問：「為甚麼？」

　　「不想讓你的同事知道我的存在，暗中給你保護比較好。」

　　「這是個好辦法。」

　　「嘿，你的自行車很棒，有變速器和雙鏈輪。」

　　「我喜歡騎自行車，所以爹送我一輛舶來貨，三檔變速自行車。我可以用低變速爬斜坡，如果用高變速下斜坡，速度便會快似飛電，但比較危險。」

　　「我的只是普通貨，沒有變速和刹車器，靠倒踩才可停車，你那輛舶來貨比我的強得多。」

　　「不一定，你比我強壯得多。」

　　「你趕快去找你的同事吧，不要讓他們久等。開會需要多長時間？」

　　「大概一個小時就可以。」

　　「我會在附近躑躅，看有甚麼不妥，如果你看見我把圍巾拉上、遮蓋面部，就不要理我，那代表可能有事發生。到時候你得立即回家去，我會駕車保持距離，給你保護，不讓你發生任何意外。」

她表示明白，接著便踏車朝學校方向駛去，我在後面跟著她。過了不久，她便到達學校，我在附近觀察，只見祥躲在郵筒後，而他的位置正可清楚地看見甚麼人進出學校。

他示意我走近，我問：「祥，有甚麼發現或要特別注意？」

「看起來非常平靜，」他說：「我們不妨去學校對面的咖啡館喝杯咖啡。」

我點頭同意，到了咖啡館後，我們選了個近窗戶的位子，可以看見人們進出學校。

（震旦）

我（敏）進入課室後，向仁濟會同事為遲到而道歉，有十二位會員等著我開會。當所有人都準備好後，我開始說話：「我們要面對的問題不僅僅是上海是否安全，而是日本人對歐美聯盟發動戰爭已迫在眉睫，如果真的開戰，日本人就會立即強行侵佔租界，會用嚴厲手段打擊報社，因為日本人害怕新聞界會向西方社會報導日本人的侵華殘暴行為。為了應對這些來自日本軍國主義的強蠻威脅，我們必須改變仁濟會的內部架構來保護大家安全，保存實力。我會把多線操作通訊變為單線操作通訊，最上層的仍是約翰、茱迪和我，其他十位主要會員將分為五個小組，每組兩名成員，指令由一至二，二至三，其他由此類推，如果有會員不幸被捕或慘受酷刑，亦不可能露底，一次過給敵人把我們全幹掉了。」

其中一名剛剛加入的新會員「金」舉手，向我發問：「我們這個架構行之有效，為甚麼要現在改變呢？」

我不耐煩地盯著金說：「仁濟會很快就會受到日軍的嚴峻考驗，雖然租界巡捕做事並不完善，基本上法律還是可以，如果日本人強奪租界，他們就絕不會對我們手軟，甚麼事都可以發生，再來個南京大屠殺亦不是沒可能，很多青幫中人已經離開租界，外國人亦放棄租界利益，趕快回國去，如果我們不加強安全意識，最終會大禍臨頭。」

金再舉手說：「可否推遲執行新組織架構？」

我立即打斷他這個不明智的建議，說：「我已決定這樣做，不會猶豫不決，約翰會立即安排小組會談，他會向你們個別去解釋新的架構和政策、聯絡方式等。」

　　約翰答道：「大家不用擔心，請跟我來，我會告訴每一位新的架構如何運作。」

　　當他們離開後，我向茱迪提及資金管理的問題，說：「你繼續負責財政，我會在不同的地方放入資金或者黃金條給你們去營運仁濟會，你和約翰要小心共同處理這些資金，不要聯絡、接觸其他會員，你現在可以離開了，有事找我，就在學生會通告板上用特別方式留言，我亦會特別留意有關音樂會的通告，這本書是解讀通訊密碼手冊，要小心保存。」

　　茱迪說：「我真的不明白，為甚麼你突然變成驚弓之鳥？顯得很驚慌，是不是租界的情況真的很壞？」

　　「我不是驚慌害怕，事實比想像來得更差，我有位朋友在租界政府高層工作，他告訴我必須認真處理日本接管租界後的安全。」

　　「你現在離開吧，不用向他們道別。」

　　看見她滿臉疑慮，我給她擁抱和吻她的臉頰說：「不要太擔心，苦難很快會消失的，願天主保佑我們！」

　　「感謝天主！」她就離開了。

　　在校外，祥小心緊盯著學校大門，沒有人能逃出他的視線，他告訴我剛剛有位少女離開學校。十分鐘後，他說有位男士亦離開學校，續說：「這個人真的很面熟，我以前一定見過他。昇，你過來看看，認識他嗎？」

　　我望了那男人一眼，說：「這個人真的好面熟，但我一時間也記不起曾經在哪兒見過他。」

　　他跟著便走遠不見了。

我告訴祥我要去洗手間，祥說他會小心盯著學校大門和附近的任何可疑人物。

當我從洗手間回來，祥很緊張指示我坐到他身旁，說：「看，這輛轎車剛剛到達，有人下車在附近搜索，好像是特務。」

我同意他的判斷，說：「我們立即用圍巾掩臉，敏看見我們這樣會立即回家去，我去拿自行車，你跟著我。」

「我沒有自行車。」

「郵筒旁有幾輛自行車，去拿一架來用。」又催促道：「走，快快！」

此時，敏騎著自行車從學校出來，看見我們用圍巾掩臉就立即離開；只見她慢慢騎車向外灘方向駛去，我心想她為甚麼騎得那麼慢，而那輛轎車也跟著她走。我保持距離，遠遠的跟著轎車，祥則隨後跟著我。

當敏到達聖母院路與巨籟達路交叉口時，她的車卻突然來個一百八十度轉向，快速駛去；那輛轎車再也不能緊跟著她，只見敏在行人道上騎著，在人群、小攤、垃圾筒和障礙物中穿插，行人看見她瘋狂的駕駛狀態亦紛紛大聲叫躲避，跟著又看見她騎車轉入碎石舖成的小巷，徒留一群被她嚇到半死、目瞪口呆的人們。沒想到，她的騎車技術超凡，沒有碰到任何人和物件，輕易便撇下轎車，使他們無法跟著她進入小巷。最後，只見她低下頭來，快速向下一條小巷俯衝過去。

我看見那兩位男人自轎車上走出來，襲擊了兩名騎自行車的路人，只為奪取他們的自行車，跟著進入小巷，緊貼著敏的方向追去；敏看見他們追來，便立即加速前進。在這條小巷內，此時一共有五輛自行車，而祥在最後追上來；他的車速不太快，但我仍然可以看見他。我回頭望時，只見一人突然拿出手槍向我開火，我本能反應的低頭，減少受襲機會；祥見狀亦加速追來，那人已停車在路中，持槍以待。

「祥，快快幹掉這無賴！我去保護敏！」在迅雷不及掩耳之際，我回頭看見祥騎車把他連人帶車，撞得半天高！我立即掉頭把車駛向持槍人，緊緊地壓著他的手，令他呼痛大叫；接著，我朝敏方向駛去，回頭看見祥已拿走他的槍並指著他，我報以微笑，說：「謝謝你，祥。」

另外一個無賴知道我追著他，可他正在緊追著敏。只見敏就像一位越野賽冠軍選手，使出超凡技術，在斜坡上奔馳；她驅使那位追逐者墮入她的圈套，明明看似可以接近她，最終卻被弄得滾到地上，沾了滿鼻子灰，只得艱難地爬起來，再次追逐她。可是因為距離太遠，我幫不了甚麼忙，只隱約看見敏一路戲弄他。當她駛到一個轉彎位置時，絲毫沒有減速慢駛；反之，她垂頭彎身，用衝力來個大轉彎，後面的追逐者就沒有那麼幸運，他在形勢上估計錯誤，最後只得狠狠地撞上牆，然後倒在地上。

我趕到那裡時，只見他嘗試站起來，便立即跳下車來控制他。他想拔槍還擊，我馬上飛身踢向他的手；這一腳非常猛烈，他的手腕也給我踢碎了，只見他臉露痛楚，眼泛淚光，爬起來求我放過他。我拿著他的槍指著他，命令站起來面壁，又在他身上翻弄，搜查他的口袋，發現了一個錢包和一些零錢；我狠狠地把他的頭壓在牆上，逼問道：「你是誰？為甚麼跟著她？你是偽警？或者是特務？」

「大爺，不要把我的頭壓得太重，它差不多要爆啦！求求你……」

從他的回話，我可以肯定他不是偽警或者特務，便轉用手肘壓向他的胸部。

「大、大爺……我只是個小混混！混口飯吃……」

「混口飯吃？吹牛！你有槍，還想殺我！」

「那是假槍，你看看，我只是用來裝裝樣子，嚇唬人的……」

當我拿起那把槍來仔細查看，果然是件贗品，令人發笑。我繼續質問他，為甚麼要追趕敏，祥便騎著自行車趕上來，我問祥道：「你怎麼處理那個混蛋？」

「我好好『服侍』他了。」

「你殺了他嗎？」

「沒有，只是打斷了他的腿。」

「為甚麼不把他幹掉呢？」

「他向我求情，說他只是個小混混，有人給他錢去嚇唬敏。」

「你有沒有問他誰要恐嚇敏？」

「他說他不認識那人，那人只是給他錢辦事，我沒收了他的錢。」祥把錢拿出來給我看看。

「告訴我，誰人要恐嚇敏？否則我就扭斷你的脖子！」

「不要！我發誓！我沒有做任何事傷害你的女朋友。」

此時，敏也騎著自行車繞回來，只見她停車在我身邊說：「謝謝你，昇，還有你的兄弟，你們救了我一命。」

「你認識他嗎？」我問敏。

「我不認識。」

「他說有人給錢來嚇唬你。」

「嚇唬我？為甚麼？」

「或許因為你父親是有錢人家，綁架你便可勒索一大筆贖金。你知道，上海現在有多複雜，甚麼事都可以發生。」我續說：「你想我怎麼處理他呢？」

那人淚流滿臉，跪下來向敏磕頭，怕得口吃地說：「大、大姐，饒……饒我一命吧！我母親年紀大，又有媳婦和兩個娃娃，如果我死了，他們就會餓死的……」

敏道：「我也不想殺你，但你要保證不會再做壞事！」

他馬上應道：「我向你發誓！從今以後我不再做壞事！」

敏便對我說：「放了他吧，他算是個可憐人。」

我狠狠地踹了他一下說：「你今天走運，她是菩薩心腸，不想傷害任何人。」再踢他一腳，又說：「快走！帶同另一個混蛋一起走！不要再讓我看見你們，下一次我可不會給你任何警告，一定會當你賤狗一樣來收拾！」

他嚇得向後倒退幾步，連忙向我們鞠躬，然後轉身飛似的跑走了。

經過這事後，我細細的想一想，然後吩咐祥說：「這個星期，你要保護敏上下班。」

「長官，保證完成任務。」

我拍了拍他的背說：「不用稱呼我長官，我們可是兄弟。」

「如果沒有其他事，我就先走了。」

「謝謝你的幫忙！明天在菜館見面。」

「好的，明天見！」

驚魂過後，敏和我一起騎著自行車回家，途中我問她：「你有沒有收到打單信或者遇到任何令你驚慌的事件呢？」

「沒有……噢，你一提醒，我又想起來了！」

「甚麼事？」

「一星期前，某天的午膳時分，當我要外出午餐時，只見有幾個人在報館外，緊緊盯著我，然後又跟著我走。我覺得此事不太妥當，就快步走回報社了，馬上通知保安查問他們，他們看見保安來，很快就分散走開了。」

「他們後來有再來嗎？」

「有，還多了兩個新面孔。」

「兩個新面孔？」

「啊，我記起來了，就是剛剛那兩個人。」

「你那時怎麼處理？」

「我吩咐保安去質問他們，然後就像前一次一樣，他們又分頭離開了。」

「不用擔心，祥會保護你，你會繼續上班吧，對吧？」

「當然會，我不是怕事的人。」

「那你父親有甚麼打算，會與你離開上海嗎？」

「不會，據我所知，他沒有這計劃。」

「是不是他與日本人和偽政府有甚麼連繫？」

「甚麼意思？你是不是認為我父親是漢奸？」

「不，我不是這個意思。我怕的是日本人侵略租界，影響到你的安全。」

「戰亂時，根本沒有人能安全。雖然我不是軍人，可我隨時願意為國捐軀。」

我望著她，從區區幾個字已令我明白，她對我有多麼真誠；但我必須把感情放下，用理智邏輯去分析目前形勢，便說：「不管發生任何事，如果你想繼續留在租界，你就應該獨個兒住。」

她不明白，於是便瞪著眼睛看著我，連路況都沒注意。

我大叫：「小心駕駛！剛才很危險，我們不如停下車來談談這件事？」

她點頭同意，便把車慢慢停下來。

「你肚子餓嗎？」

「有一點兒。」

「再轉個彎，有個我幹黃包車伕時常去的麵檔，我可喜歡那裡的陽春麵和湯水了！就像我母親給我弄的，差不多一個味兒。」

敏感受到我對母親的掛念。當我們下了自行車後，她驚喜地給我擁抱，並在我臉頰上吻了一下，說：「不要回想過去，它會傷害你，親愛的。」

我點頭說：「不用擔心，我很好，就把自行車放在這兒吧。」

麵檔小販很高興見到我，又馬上用抹布擦了一張桌子給我們用，對我說：「很久不見了，歡迎你回來！」又續說：「還是照舊的陽春麵嗎？」

說罷他又看著敏，不知該如何與她打招呼。

我說：「她是我女朋友，同樣弄一碗給她，份量少一點。」

「好的。」

「我想，你應該會喜歡吃的。」

「我喜歡你喜歡的所有東西⋯⋯只有一樣不能接受！」

「甚麼東西不能接受？」

「我不能接受你的情婦！」

「噢，我的天！」我詫異得張大了口，不知應該說甚麼，只是傻傻的說：「噢，我的天！」

稍稍定神後，只好安慰她道：「沒有，我只愛你，沒有其他人。」

幸好，此時麵檔老闆給我們送上麵來，放在桌上。他看起來有點不安，可能是聽見我和敏剛才的對話；所以他給我們送完食物後，就趕快離開，再也不看我們。

敏卻微笑說：「在公眾場合不要大聲談論我們的事，你要身體力行。」又續說：「從現在起，我們暫緩爭辯，不再談這事了。談談將來幹甚麼吧。」

「好，那我再說一遍，你要自己獨立居住。」

「為甚麼？」

「現在你幹下的是秘密組織，對日本人和偽政府產生威脅；如有任何差池，首當其衝的就是你的父母。」

我停下來看看她的反應，想知道她是否意識到目前的危險；她很快便瞭解到如果繼續下去，一定要有警覺性和危機感。我看著她內心掙扎了好一會，幸好最終她想通了。

「那我要住在甚麼地方？」

「你搬去閘北區住較好。」

「你意思是要我搬離租界？」

「其實，假如日本人佔領租界，那住在任何地方都沒有分別，都只能無奈地接受那些令人痛恨的對待。從理性思維去想，他們一定會用鐵血手段對付新的佔領區，以展示他們的力量，然後加大力度統治。閘北區就不同了，他們已佔領那兒四年多，地方管理、行政工作已交由偽政府接管。由於是偽政府管理，壓力就少很多，因為他們做事馬虎又貪腐，這反而對我們地下組織的工作更有利。」

「嗯，有道理，那你有甚麼打算？」

「我很快亦會搬走，去閘北區找一間公寓來住。」

「你說你會搬離青幫給的豪華大宅？哈，那會不會降低你的身分呀？」

「敏，你常用這個話題來譏笑我。」

「對不起，我沒有這個意思，只是隨便說說。」

「如果你同意，我可以幫你找個公寓。」

「房價是否昂貴？」

「看你要多大的面積了。」

「一般的就可以了。」

「我明白了，現在我先送你回家，你跟你的父親談談這件事吧。」

「那你明天下午可以來我家嗎？我不用上班。」

「好啊！」

我們付款後便離開麵檔，騎自行車回家去；送她到家門口時，我下車跟她說再見；突然間，她抱著我，吻住了我的唇，我緊緊回抱著她說：「我愛你。」

她輕輕把我推開，說：「今天很晚了，你快快回家吧。」

我真得捨不得，但亦要無奈地騎自行車離開。

This is a draft of my new novel

'The Lost World's Love'

The Battle of Shanghai

Shanghai – a city where people 'drink to live and dream to die!" – is the most beautiful, out-of-this-world and mysterious place on earth. Its unmatched beauty has survived and evolved through eras of glory and hardships. It is fascinating, full of hopes of adventures and untold kinds of opportunities. On the other side of the coin, the streets are full of countless accounts of broken hearts and heart aches of all descriptions. No matter how people look at it, most in Shanghai have their own dream that acts as their personally focused aim to drive them on, almost oblivious to all that surrounds them. It is this drive that allows them to survive the Japanese invasion. No matter how difficult the situation becomes, Shanghai's charms have never been diminished – it is truly an undefeated city!

As the Japanese invasion set in, it brought with it the occupation of the Three Northeastern Provinces. Chinese students demonstrated and staged mammoth protests in Shanghai. On 28 January 1937, the Japanese navy bombed Shanghai. The Chinese national troops fought back strongly to protect Shanghai. A ceasefire was reached shortly afterwards, but was broken in May. On 13 August 1937, the Japanese invaders started what became known as 'The Battle of Shanghai'. Our regiment was composed of 800 soldiers and was ordered to protect the Sihang Warehouse to halt the advance of Japanese troops for at least four days from 26 October. The Sihang Warehouse was situated on the south bank of the Suchow Creek which also bordered the International Settlements. Our company was not consigned to the battlefront, but to guard the regiment commander and to facilitate communication with the various regiments on the battle lines. It was our job to monitor and report

battlefield logistics from the Sihang Warehouse to the various regiment positions, and to co-ordinate the supply and replenishment of ammunition to the battlefront. Our snipers laid in ambush well above ground level to offer us protection and to pick off any Japanese soldiers who strayed too close to our compound.

The First Company Captain called to me with his gruff voice, "Come to me quickly, Sheng."

I ran to him, stood to attention and replied, "I'm here, Captain."

Although I was standing still, my eyeballs searched the inner recesses of my brain as I wondered what could be afoot that demanded such urgency and gravitas.

The Captain squealed at me, "Lay down by me, man, and get your bloody head down. I don't want to see it blown off like a flowering blossom firework by a Japanese sniper!"

He continued to explain in a more constrained voice, "Battalion 1 commander ordered me to cover a girl-guide to come here on a special assignment."

I responded with my curiosity barely hidden. "A girl-guide?"

"Shut up! You sex maniac! This girl-guide is going to carry out a sacred mission."

My face went red as I queried this notion with an air of astonishment in my voice, "a sacred mission?"

The Captain sent a dollop of phlegm into the breeze and said, "that's right, she's going to bring us our National flag to boost morale and to send a message to those goddamned news reporters to let them know we mean business so they will write something about this battle."

He continued to speak faster, "Mok is out there snipping Japs' bloody heads and you'll tell him to cover you for this mission."

He turned his eyes wide and spoke in a rough voice, "For Hell's sake don't let the girl-guide get shot by little Japs, or I'll blow off your ball with a grenade!"

"Yes, captain, your will is my command!"

I saluted him, turned around and took off.

He shouted loudly after me, "Keep your eyes on the bridge from the Settlement. Take more grenades."

In my haste, I turned my head back and shouted, "Yes, captain."

Well aware of the dangers ahead of me, I kept my head down and moved like a rat over the roof of the warehouse. Mok, seeing me slithering along, waved frantically and put his finger to his mouth, whispering "Shhhhh! I have a little Jap who is hiding under the bridge in my target."

He continued, his face puffed, eyes sparkling, and turned back to face the river. He squinted his eyes at me and said, "When I move, follow me or you'll lose your ass."

It was quiet as dawn drew near after an earlier fire exchange of mortar and machine gun fire with Japanese troops. Without the slightest movement, "Bang! Bang!" Mok blew two shots at the river. I saw a seagull fly over the bridge, frightened off by the gunfire.

"Idiot, move and roll over to this side," Mok shouted at me, and at the moment I made a move, bullets flew over my head like whistling stars.

"Move, move, move!" Mok shouted again.

We changed from place to place until we found safety in a corner covered by a sandbag wall.

After the shooting, silence returned. Mok held the gun in his breast, panting heavily, and said, "You silly man, you almost got killed as you exposed our position to the Jap snipers."

He continued, adding with a smirk of satisfaction on his face, "I should have killed those two little Japs!"

"Why did you come here?" he asked.

"Old Dad wants me to bring a girl-guide here, and you need to cover me against those little Japs sniping at me."

I could see in his eyes this explanation bewildered him, and I understood what this notion posed to him as he strived to come to grips with it. I attempted to repeat what Old Dad had told me, but was cut short.

"You can't go out like this!"

"Why?"

He replied, "Let me finish. No questions."

I nodded.

"In the warehouse, there are not only soldiers, there are also civilians – staff and workers, quite a few of them."

He paused and looked at the river again.

Following his line of vision, over the bridge I saw a man running towards the bridge jump into the river. Very soon, he disappeared out of sight.

Mok said, "This is exactly what I wanted to tell you. During the battle, there are civilians who have to run away from the warehouse. Of course I can't shoot them, because they are Chinese.

"And the Japanese don't shoot them either." I looked at him doubtfully.

He said, "I'll tell you why. It's very simple, the Japs don't want to expose their position by shooting at civilians; it's not because they are kind, or have any respect for our civilians."

"I see." I nodded in appreciation.

"I want you to change into civilian clothes. I got these from the workers' changing room. Put them on and dress up in them, and the Japs mightn't shoot you."

He looked at my weapons, "You won't be able to carry a rifle or grenades."

"I'll give you my pistol. It's a Magnum, and here are some bullets. Easy to carry! Take your knife with you too. When you get down to the lorry parking area, I can cover you. But don't you dare look back at me. That'll expose my position. Find your way out to the river side. Don't walk over the bridge; only dogs walk on the bridge. You'll be a sitting-duck target if you do that! Swim to the other end and you'll land in the International Settlement where the little Japs won't try to shoot you. Then you're relatively free to go off and find the girl-guide. Do you remember a hotel called 'The Palace'?

"I'd say she should be there somewhere. When you see her, tell her you are a soldier who has come to assist her to get to the warehouse. There are two ways to come back; swim or climb through the support structure beneath the bridge. You should be safe as long as there aren't any Japanese under the bridge. If you see a little Jap, take him out. Don't shoot unless it is absolutely necessary. Use your knife instead."

This was invaluable advice that Mok gave me. I changed into civilian clothes and hid the pistol in my waist pocket, and secluded the bullets and knife on my body.

He shook hands with me and said, "Don't look back. I will protect you."

I couldn't stop the tears from streaming down my face as this was such a real life-and-death friendship.

He comforted me by slapping me on my back saying, "Young man, Old Dad knows me, he asked me to look after you so that you can successfully complete this mission. This is important, not only for the sake of the National flag. It is the demonstration of bravery to the whole world. We are not scared off by the invaders; as soldiers, we protect everyone in this peaceful land. So we need to win this war!"

He then said, "Go, go! Don't look back."

This sentimental moment filled my eyes full with tears again as I walked to the ground floor level of the warehouse.

> *Love At First Sight*
> *A man goes with love to the battle;*
> *His courage is not a prattle.*
> *Touching upstanding over every person's heart;*
> *Fighting is the mission for all Chinese to start.*
> *A brave girl who brings the National flag;*
> *To show to the world she did it without regret.*
> *Though it is the darkest moment;*
> *Dawn with breezes comforts everyone with sentiment.*
> *Pray, pray for this young soldier;*
> *As well as for the brave girl-guide in their venture.*
> *They showed to us their empathy;*
> *And won our heart of sympathy.*

The Lost World's Love

I arrived at the ground floor level of the warehouse, wondering where to go from there. I met another comrade-in-arms called Leg. I told him how I was ordered to carry out a mission in the International Settlement and be back within the hour before the sun's dawn rays broke through heralding a new day.

He reminded me to be cautious of the Shanghai Municipal Police (SMP) as they would arrest me if they knew I was a soldier armed with weapons. He told me to scurry along the line of destroyed trucks and carts as cover to protect myself. He would watch over me and guide me on my way back. When I returned, he advised me to wait at the back of the damaged empty guard house for his signal before making any further move forward. I thanked him for his assistance.

It was still dark with not a hint of moonlight. The lorry holding area had been almost completely devastated by fire. Our Regiment had fought hard and valiantly to keep this area under our control. Luckily, this spot was within eyesight of the International Settlement, and Japanese troops hadn't dared to use chemical weapons or heavy artillery which gave us the relative balance of strength in this battle. I scurried to the broken trucks like a mouse. The two little Japs that Mok had killed were now lying on the embankment of the river. I could hardly hold my temper back from kicking the corpses. Had not a great mission not been in front of me, I would have taken this liberty to release some of the pent-up antagonism the little Japs had conjured up in me!

I climbed through the under-structure of the bridge without much difficulty and arrived at the Bund where I saw the Palace Hotel near Nanking Road. The Palace was the choice of rich foreigners and many of them chose it for their accommodation. Not many pedestrians were on the street. Not far away, there was a checkpoint where a few SMPs were stationed to stop those

who approached. It all proved a challenging task for me, to look for a girl-guide whom I had never met before amidst such surreal circumstances. I had a mental picture of her as a young student type.

While I was looking around, I heard a kid's voice calling me in a high-pitched tone, "What are you looking for?"

I looked at this baby-faced tall young boy, about 14 years old, and he kept staring discerningly back at me.

"Yes?" I replied in a low voice.

He bid me to follow him. We walked close to one of the side doors, around the kitchen area, of the hotel. He stared at me for a while and I could tell he felt some unease about me.

I said, "Don't worry! I'm looking for a girl-guide."

Happiness spread over his face and he called, "Yeah! Sister, come out, a man has come to fetch you!" My eyes opened wide. Out came someone who resembled a delicate beautiful statue – a long-haired young girl dressed immaculately in well-tailored girl-guide uniform. She was not very tall, about 5'4", but her face was illuminated by her cherry red lips and a broad smile exposing a set of gleaming white teeth. Although her demeanor hinted at shyness about her, I detected in her some kind of attraction to my presence. The thoughts of Old Dad who continued to remind me, 'even if dressed in rags, I would still be handsome', sprang into my mind. Some form of electrical spark was ignited on this first meeting that I was not fully aware of at the time.

She introduced herself, told me her name was Wendy and the young boy was her brother, John. She continued, "Your commander told me to wait around here to be collected for a short mission. I believe I am to be back within the hour."

John now seemed very sad as you could see the fear in his eyes at the thought of her embarking on this mission. He held her hands tightly and said, "You must come back safely." A pool of tears had now welled up in his eyes.

I patted him on his shoulder and said, "I will return your sister without losing a tiny piece of her hair!"

She warned her brother before leaving, "Don't go too far from here. Hide and keep away from the SMP. I will be back soon!"

I asked her what she was carrying.

She replied, "I have the National flag, a rope and a small knife."

"Oh, the rope will be useful to me. Would you mind giving it to me please?"

I told her that my plan was to get as close as possible to the bridge. Our men should have cleared the area to make sure that it was free from Japanese soldiers. I explained that we couldn't walk over the bridge as it was far too exposed and would make us a target to be easily picked off. Therefore we would have to climb through the structure underneath the bridge. Furthermore, when we reached the other side, I explained the importance of how she should keep as close as possible to my back, even while we're waiting until we got the signal to move. I advised her to hold the rope tightly at all times and avoid letting go of it. I also reminded her that she might see some corpses during our attempt to get to the warehouse so she wouldn't become hysterical at the sight of them and thus arouse the attention of our enemy. She nodded to indicate she was prepared for such encounters.

We hastened along snake-like, close to the ground, as low as our bodies would allow. She tightly gripped one end of the rope while I held the other. It was a strange feeling at the time, having this connection. When we arrived at the bottom of the bridge, I turned my head and saw her face reddening. She was blushing.

I asked, "Are you scared?"

She replied in a sweet voice, a voice I had never heard before, "No, I am not, because of you!"

Her voice mixed with her breath was like a whiff of perfume. Sweet smelling and somehow illusionary. However it was most important for me to keep concentrating firmly, and not be distracted by passing whims. It was a life or death situation after all. Two lives were held in the palm of my hand. I couldn't afford to lose concentration for one second.

As it turned out, the task of mounting and climbing through the structure beneath the bridge was carried out more or less effortlessly. We didn't encounter any hiccups to hinder our advance. In seemingly no time at all, we were safe on the other side of the river without raising the attention of Japanese snipers. Suddenly Wendy clutched onto me and held me tightly, causing my heart to throb in quick palpitations.

I spoke to her, our mouths almost touching, as she held me close, "What's the matter?"

She closed her eyes and said, "A corpse."

"Don't worry, it is a dead Jap."

My immediate impulse was to kick that corpse to give vent to my anger. She nodded. When we had almost got to the damaged guard house, she screamed, and I raised my palm to cover her mouth, wondering what the hell had happened. The Japanese soldier was not yet dead but had been laying there in a state of semi-consciousness. Awoken by our presence he had taken out his pistol and was aiming at us. I instantly dragged Wendy down from her standing position and dived to cover her with my body. The capacity for reaction under pressure is an inexplicable thing for, along with protecting Wendy in such a dramatic way, I had simultaneously snatched my knife from its hidden location and sent it darting like an arrow to a bulls-eye hit to his heart.

"Thank God, I got him!"

I tossed the corpse to make sure he was dead: dead like the other Japanese we had encountered on this foray.

Then I went back and told her, "There are no more live Japanese here. We are safe!"

By this stage I was about to signal my comrade that we were ready to return. "Bang! Bang!" I didn't need to turn my head as I felt the thuds on the ground as two more Japs were taken out with single shots.

I murmured in a pretty low voice to myself, "Thanks, Mok, you've killed two more little Japs. No wonder everyone said you are a crack shot!"

Leg, who was on the ground floor level of the warehouse, gave me a hand signal, indicating me to move. I instructed Wendy to follow me closely.

We had lost track of the rope by this stage, so she held me tightly as I carried her across the last part of the way, saying, "We are safe!"

When we were inside the warehouse, I saw her cry.

I comforted her, "Why are you crying?"

"This is the most unforgettable moment in my life!" she replied.

"What makes this unforgettable?" I enquired.

Her face went red and she became very shy. "The shooting!" And how close to life and death things really are.

"Would you like to take a rest before going to see our Region Commander?"

"No." was her reply.

"Well then, get moving." I turned my face to her and said, "Do you need the rope to guide you now?"

She hesitated for a while and said, "You are a bad boy!"

I shook my shoulders and said, "I beg your pardon!"

She replied in a very clear sweet voice and a look in her eyes, "Forget what I said!"

> *The Rope*
> *Round rope, round rope tightened tightly tight;*
> *The stranger on shore with love at first sight.*
> *Hands on rope like a lock to their heart;*
> *Troubles occurred can't make them apart.*
> *Sweet memory to start;*
> *Fate isn't a story of arts.*
> *The soldier in the war time;*
> *Hopes to see the girl without clues to find.*
> *The prisoner of love can't evade;*
> *The chain of his beloved in her way.*

I brought her inside the command centre where Commander Xie was waiting for us. I saluted him and said, "Second lieutenant Sheng completed the task and the girl-guide Wendy and the flag arrived safely."

He said, "Well done!" He shook hands with Wendy and said, "You are a brave girl. Everyone in the regiment is proud of you, Shanghai people too!"

Xie said, "About 40 years ago, the Qing Dynasty was defeated in the First Sino-Japanese War (1894-95), resulting in China losing vast territories to Japan. This time, we can't afford to lose an inch of land to the Japs. We will win and expel the Japanese back out to the sea."

Everyone was very excited at hearing this.

Sheng said, "Let's sing a song to mark the flag-raising ceremony. And I can play it on the bugle as well."

Xie said, "That's a good idea. Let's do it quickly."

As Sheng took a bugle from his bag, an officer called out to the soldiers to fall in for the ceremony.

He shouted loudly, "Salute!"

Sheng began to blow his bugle.

He shouted again, "Let's sing 'Brave Girl'!"

Everyone sang along:

> *Brave Girl*
>
> *Brave girl*
> *Here comes a brave girl!*
> *Sends a flag in wonder*
> *Oh, invasion is blunder*
> *We roar like thunder*
> *We have the right to justice*
> *Evil minds end in crashes*
> *No worry to gunfire*
> *You are a brave girl*
> *Flag is the spirit of bravery*
> *No complaint, no sound*
> *Power to overcome enemies*
> *Strong wind blows our flag*
> *Flag makes us stand our ground*
> *You are a brave girl*
> *It is the wonder we've got*
> *We are brave Chinese!*

After the singing was finished, Sheng called out to raise the flag. It was tied to a bamboo pole that was held firmly by Sheng. He waved the flag in the room. Commander Xie ordered Sheng to bring the flag and put it out of the window of the warehouse.

Xie said, "People in the Settlement can see the national flag of this regiment and be proud of us for fighting the little Japs."

We clapped hands.

Xie said, "This area is too dangerous. You should take Wendy back to the Settlement now."

I said, "Yes, sir. I promised that she would be back safe and sound within the hour."

I looked at Wendy whose feeling quite vulnerable now. She had tears in her eyes. She shook hands with Xie and others in the room. I went up to her and said, "Let's get back to the Settlement."

She nodded without saying a word. From her looks, I felt she didn't want to leave. I said, "We should go now."

Nothing out of the ordinary happened on our exit from the warehouse.

For some strange reason, all went smoothly until we almost reached the other side of the river. Seeing two SMPs I raised the palm of my hand to cover her mouth. One SMP held a torch which he was using to search the under-structure of the bridge for any sign of movement. Leaving us no choice, we had to descend into the murky depths of the river.

I notified her quickly of our course of action, "Take a deep breath and hold it for a while. We have to dive under the water to avoid the SMPs."

She glanced at me with a perplexed look on her face. It was at this point that I became aware that she had placed her life in trust with me. We bobbed

along, half-diving and half-swimming. By the time we emerged from the water, the SMPs were gone. I knew she must have been exhausted by this stage, so I asked her if she would let me carry her on my back to look for her brother.

"Are you cold?"

"No, I am not!"

I wasn't sure whether she had only responded it this way so as not to further inconvenience me, or whether she really meant it. Soon we were back at the Palace Hotel. John was there waiting and crying to himself. Immediately he set eyes on us, he snapped out of it and asked what was wrong with his sister.

"Nothing, she's just drenched and cold. We had to dive into the river to escape from the SMPs."

By now Wendy had regained her equilibrium; she stood up and thanked me for my help. I leaned over to her ear and asked, "When will I see you again?"

She said, "If you believe there really is an affinity between us, you can come and find me. I am a student of Zhen Dan Women's Art & Science College."

John gave her a jacket and motioned her to leave as quickly as possible. News would soon break out about how a girl-guide had sent a National flag to the National army in the Sihang Warehouse to boost their morale and to send a positive message to the world that the Chinese would resist every attempt the Japanese made to dominate them. But there wasn't any news about a powerful new love emerging in such unusual yet fertile conditions; such a budding love that melted two young lovers with a rope immersed in a love river in a continuation of a pre-destined love story.

> *Destined Lover*
>
> *The destined love story comes to life;*
> *Bound by rope fostering mutual desire and hope,*
> *Immersed in a river of love with hopes to survive.*
> *News not published but feelings etched deep into heart,*
> *No one, in truth, could possibly tear them apart.*

A premonitory precursor pricked me to keep her close, but I was forced against intuition to tell her to leave quickly. She nodded and took her leave. Her body began to get smaller and smaller as she drifted off into an ethereal distance. Her hands waving in the sky gradually faded to twilight invisibility. In my brain, her face, her voice, her smell never left, but stayed with me as a reassurance to all we had experienced together.

"She is the centre of my dreams. A dream lover who was to torture me in such a thorough fashion armed only with allure, and not a weapon in sight!"

The next day, unfortunately dreadful news broke out about events in Shanghai. News reporters sent cables back to their home countries. Shanghai had fallen into the hands of the devil on 12 November 1937.

The Aftermath

The battle continued to get fiercer as the casualties mounted on both sides. Our regiment sustained heavy losses as more than half our men were killed, and our ammunition and supplies were desperately low and running out fast.

On the sixth day, Old Dad huddled close to me and confided with me in a deeply serious, if not despairing, tone, "Sheng, at this rate we'll be finished soon! Plus we have been forbidden from joining the National troops on their retreat to Nanking; our company especially, due to our function and role, has been ordered to disperse, and to leave no trace of our operation.

I'm telling you this strictly on a person-to-person level as I want you to be given the opportunity to pledge your loyalty to the KMT and the State."

"You do understand the importance of this?" he added to further emphasise the serious nature of this offer.

Being so certain of my situation, I replied directly, "I understand my capacity as a soldier, I have already done what the State and the army wanted and expected me to do. Beyond that, I don't know how else I could possibly contribute!"

My response had an obvious effect on him for he presented a new serious side to me I hadn't witnessed before. Speaking to me in hushed rounded tones, his usual colloquial brashness had evaporated as he unveiled his plan and hope for me, "I want you to go undercover as our agent in Shanghai. At the start, you'll have to work on your own with no one else to help you. You won't be able to rely on help or support from old friends for, in the first instance you won't be able to distinguish between those who are 'living mortals', and those who are 'ghosts'. Best tactic is to assume they are all 'ghosts' first up. Apart from that I will be the only one to contact you. Should I die, you will be free, but you won't have an identity as no one knows you're working for the KMT."

A vacant nodding of my head was the best response I could come up with.

As if he hadn't already sent me into enough of a state of shock, he continued, "You won't be entitled to any retirement, no pension, your records will cease to exist, nothing. Do you still want to do this?"

However this last question scuttled all my fear for I immediately responded with, "Old Dad, I was homeless orphan that was left to make my own way in the world since I was a child; if it wasn't for you, I don't know where I'd be today for you were the only one to help me through those difficult times. I look on you as my father, and I will do whatever you want me to do."

"Good lad, I knew I could rely on you. Here is some money. Take it with you. When you feel comfortable and safe enough, try to get a job on the wharves at Terminal 16 or somewhere like that so you can get some identity papers. Check out the notice board for recruiting workers there; they're always after people. Keep checking the notices to find the right kind of job. Try to get a job as a mechanic or technician on a ship plying the coastal waters. That would be an ideal cover for you. I can then contact you by a note on the notice board in the terminal requiring someone to repair a white yacht as messages for our arrangements. The messages will be encrypted in army's code. If you haven't worked with the code before, please study up on it. It's not that difficult but you need plenty of practice to be good at it."

"Yes, I do know it, but I do need to do more practice."

"You can't go walking about carrying the pistol Mok gave you. You'll be in big trouble if the SMP or Japs find you with it. But, for Heaven's sake, don't throw it away; stash it in a safe place so you can use it someday when it's needed. Quickly now, get into civilian clothes and make tracks. There is no need to say goodbye to anyone. Leave without telling anyone."

He added, "In fact, everyone is running away. No one has to know what you're up to, or where you're going. Go now, clear your mind, remember your roots; you are a peasant child who was abandoned at birth. Remember the details. If a SMP asks you, just tell him you are a casual worker at Terminal 16. There are many workers coming and going from there every day and every week. No one knows who's who? The rest relies on your survival skills."

Old Dad nudged me to leave as he tapped me on my shoulder, saying, "Be cautious all the time. I'll see you again soon!"

When the battle ended, peace did not return to Shanghai. Far from it, the city had become much more tense and complicated. Rumours spread like wildfire on a daily basis about real and imagined consequences the war was further engulfing the city into. The Settlement Administration became quite agitated and concerned about their relationship with the Japanese. Japanese troops had breached their previous state of détente with the foreign nationals by invading the Settlement to take control of the eastern and northern districts. This included the area in the Hongkew, of which the Whampoa which was controlled by the British and the Siccawe controlled by the French. This added further fuel to what was an already raging firestorm, with the wild speculation and rumours that took root: the British and American colonies in Southeast Asia like Malaya, Singapore, Hong Kong and the Philippines would be the target of unbridled Japanese expansion and colonisation at any moment now.

The Battle of Shanghai was a disastrous war that had a global impact of immense proportions. The Chinese National Revolution Army (NRA) lost 200,000 soldiers, while the Japanese lost about 40,000 soldiers, and this proportion no doubt can be explained by the sheer brutality and barbarous nature of the Imperial Japanese Army. And not only did the carnage stop there for there were over half a million casualties, both military and civilians. The fierce resistance the Chinese forces countered these hostilities however caused the Japanese invaders to extract a high price on other battle fronts in China.

During the Shanghai battle, the Chapei and Hongkew became the battle front lines. On the military side, the NRA suffered dreadfully through the various larger battles resulting in an almost total reduction of its elite troops. In one battle alone, the NRA had lost, within three hours, nearly two-thirds of their soldiers. Luckily for us, and due to our special role, our regiment was one of the few that did not suffer that many casualties. On the international political front, the attitude of Western leaders changed when they saw the grit and determination the Chinese army put up against the Japanese. They had always thought it would be a fait accompli and the Japanese would merely walk in and take over China. Suddenly it was a whole new ball-game and this caused a great deal of shock and consternation with the Japanese military along with their politicians.

During the battle the Chinese people were granted no mercy from the Japanese. People living in the Japanese occupied areas were maltreated. Women were raped. They had to face unnecessarily cruel punishment, starvation, slave labour conditions, cruelty, loss of property, and arbitrary firing squads. NRA troops were forced to withdraw from Shanghai and move towards the western territories to provide defense back-up to protect Nanking – the Capital. Unfortunately, as weapons, ammunition and supplies were not replenished, the troops were overwhelmed by the better equipped Japanese invaders, forcing the move from Kunshan to the Wufu Line on 13 November 1937. After a solid month of interminably ferocious fighting without air-defense, Nanking eventually succumbed to the evil hands of these relentless invaders on 13 December 1937. At that time, Nanking was in the heart of winter's extremely cold icy conditions. Encircled and trapped by their Japanese invaders, NRA troops had little success in breaking through their lines. As a result, over 100,000 soldiers were captured and summarily put to death. The huge debt of blood owed to the Chinese by the Japanese, included over 300,000 lives lost in Nanking. The Nanking Massacre was a war crime of immense proportions. Needless to say, this was only a beginning. Battles raged for another eight years before China was able to claim its own land, along with its honour back.

In Shanghai, almost all areas in the Chapei were left as burnt-out shells; roughly seventy percent of the areas of the Hongkew and Yangshupu including Wusong were damaged with many left unrecognisable. More than 400,000 refugees escaped from destroyed homelands to seek refuge in the International Settlement. I was part of a wave of refugees that made their way there. Due to a most unusual mixture of circumstances and happenstance, the International Settlement enjoyed a level of prosperity that sat in stark contrast to all that surrounded it. Inside the Settlement it seemed as though the war was taking place in another country. The Japanese established a puppet state called the 'Great Way Municipal Government' in Shanghai with its puppet capital located in Pudong on 5 December 1937. To keep away from harm while in Shanghai, I had to establish a new identity for myself.

My best chance, it seemed to me, was to get a license to operate a rickshaw. This also would have the added advantage of making it possible for me to move freely around the city while buying time to plan for my next move. I also went to the wharves on Whampoa River where Terminal 16 was located to search for jobs and any news that might have been left there for me on the notice board, but nothing eventuated during this early period. I went to the rickshaw depot to ask for jobs several times but didn't have any success at that neither. Nevertheless I was ever vigilant to keep from being seen by the SMP, or those spying for the Japanese.

Then, one day in the early summer of 1938, while I was at the rickshaw depot looking for a job again, something happened out of the blue. I had been wondering what to do when suddenly I heard someone call my nickname. I turned, and to my surprise, a former soldier colleague was running up to me. I instinctively pulled my hat lower over my forehead to shield my face in an attempt to evade him. But this didn't fool him as he stopped me in my tracks, and said, "What's wrong with you? Don't you care about your old friends?"

Trying to hide my embarrassment, I said in an off-handed whisper to him, "Course not! I am worried about the SMP, and spies who may be on the lookout for ex-NRA soldiers."

The moment he heard me saying this, his face turned serious, and he bade me with a hand gesture to follow him. I pretended nothing happened and followed him. We stopped at a noodle stand. It was early in the morning, and there were not many customers. We ordered individual bowls of noodles and I ate away like a hungry ghost, slurping and burping, with the soup dripping and running down the corners of my mouth. We spoke in a hushed tone with our heads lowered inwards, nearly touching each other.

He confided his worries and concerns to me, "Sheng, whatever you do, don't mention a word about the NRA to anyone! If you do and they find out they'll send you direct to jail, or even worse, they will put you in a jail run by their notorious spy agency, the "Kempeitai" – They operate out of the Military Police Corps on Sichuan Road North in Wing Lok Square."

I responded immediately on hearing this name, and mumbled to him, "The Kempeitai?"

His answer came in a clear well-articulated tone, pronouncing each syllable to heighten the sense of fury this place conjured up in people, "A place which forces one to walk in upright, but to come out packed in a bag!"

"Packed in a bag?" I stammered.

"A bag for a corpse, you idiot."

"Oh!" These words sent hot and cold shivers up my backbone from the tip of my toes to the top of my head.

He went on, "Don't open up to anyone. You must hide your background completely."

I nodded in agreement and then asked, "What are you doing in Shanghai anyway?"

I said, "I was summarily dismissed and ended up a homeless statistic, but I need desperately to get a job to make a living."

"Hey. How about that? You could wear a rickshaw-man jacket, No. 239. Cheers, consider yourself are a rickshaw man!"

My mind became clearer. Until this point I hadn't realised he earned his living as a rickshaw man.

"Yes, like you, I have to do something for a living."

He took a pause and said again, "I was lucky; I met an old primary school friend who had no idea I was an ex-NRA soldier; so he got me this job. But he's had to leave Shanghai to return to his home village at short notice."

"It would be a convenient and opportune vacancy for you if it's still available!" He hurried me to finish my noodles, saying, "Finish your noodles quickly and let's get moving." I was thrilled thinking I might get a job soon.

On arrival at the rickshaw depot, he introduced me as his old school friend and had a lot of good things to say about me.

The foreman cocked his head to give me a good going over from head to foot and then said, "You look strong enough, but are you happy to share one-third of your income with me? That's the big question."

Before I could even open my mouth to form an answer, my friend, jovially responded on behalf, "Certainly, and not a cent less!"

He pushed my head and said, "Young man, kowtow to show your appreciation."

The mere thought of kneeling down to him sent a surge of resentment through me. Fortunately he didn't push the issue as I heard him say after sensing my reaction, "No need to do, just be smart and keep your eye on the ball!"

"Yes, sir!" was my feigned reply.

To this, he smiled slyly, and added, "Any benefit for me today?"

My friend immediately reached into his pocket and pulled out some money to him, "Here is just a little, as a token of our obligation to you. I am sorry this amount isn't enough to buy a pack of cigarettes, but at least it's a sign of our good intentions."

He continued, "As we move forward, the more income you earn, the more your obligation will be diminished and the more respect you'll gain from me, along with the money will flow your way."

He enjoyed this moment of brinksmanship and unchallenged control he held over me. then drew a form from a drawer before telling me to fill it out with my details such as name, age, and so on.

After I finished the form, he took out his stamp to seal the agreement, all the while staring at me, and then he exclaimed, "You are lucky, I am feeling top-of-the-world today!"

He raised his hand high above his shoulder, paused and then 'Bang', the seal struck on the form as he said, "You are a rickshaw man No. 454; follow Siang, to get your rickshaw and the jacket, and start working today. Siang, tell him about all the rules. Go!"

I bowed to him honourably, and said, "Thank you very much. I will do a good job."

We left the rickshaw depot with me feeling on top of the world as at least I had a job now. I looked over to my friend Siang and he, with a degree of seriousness in his voice, said, "You know, it is very difficult for people like us to find a job here, and the license of a rickshaw man provides you with an identity."

Caught in his stare, as much as I tried to respond to his insightful observation, my face muscles had locked up leaving my eyes fixed in his line of vision, speechless. My eyes became pools of tears.

He tapped my shoulder and said, "From today, let bygones be bygones. You're a rickshaw man now."

A new level of kindness was revealed to me with him telling me everything in a most helpful manner – fares, main districts, main streets, famous buildings, restaurants, night clubs, and so on.

At one point he paused and with a barely visible gulp sent on to say, "Don't hang around on Shanghai Sichuan Road North, unless you have a booking or a customer on your rickshaw."

"Why's that?" I found myself asking due to the very dire way this information was conveyed to me.

"These are forbidden areas where much skullduggery between the movers and shakers takes place, and the area is infested with spies and secret police. It also contains a key intelligence base of Military Police Corps which operates from there. If they suspect you are a KMT, or communist operative, or you are going to cause them trouble, they will arrest you on the spot!"

He continued, "Don't risk your life, give the area a wide berth!"

"No, I won't!"

The Mission

It was a sunny morning as I went over to Terminal 16 in my rickshaw to see if there was any information left for me from Old Dad. This was another of my almost daily trips as Old Dad told me he would leave me a message by our arranged means. The Shiliupu passenger terminal and associated markets on the Huangpu River were built and had been in operation since the Qing Dynasty. The original plan was to build twenty-seven terminals and for unknown reasons, only sixteen terminals were built. Terminal 16 was the biggest one and became the busiest terminal for passengers and freight.

While searching the notice board for jobs and other pieces of information, my eyes were caught by a notice at an unobvious corner asking for someone to repair a white yacht. Immediately I realised I should take it off quickly without causing any attention. I pulled my rickshaw over to sit in a quiet place while I tried to make sense of the message which had been written in army code. The message read, "See me tomorrow in Chenghuang Temple at seven o'clock." I was so excited to know that I hadn't been forgotten by my colleague. I had trouble sleeping that night.

Around five o'clock the next day, the urge to get ready and travel to Chenghuang Temple for this appointment had overtaken me. At the time I was renting a room from a woman of about fifty, who was a widow. She had told me that her husband was a peddler trading goods all over the region. Then one day in 1935, he was caught in gunfire between NRA soldiers and Japanese troops. Unfortunately, he was killed by Japanese soldiers. Adding to her list of misfortune, she went on to tell about her only son and the fact that she didn't have a clue where he was. She thought he might have joined the forces but wasn't sure whether it was the NRA or Communists. She added that as long as he fought against Japanese invaders, she didn't care whether it was for the NRA or Communists.

"Sheng, would you like some sticky rice roll and steamed buns before going to work?"

I said, "No need, it's too early for you to make this for me."

"It's no problem! It only takes ten minutes to get ready."

I replied, "I'll come in a second. Thank you."

This landlady was like a mother who treated me like I was her son. Many things, including grief and marriage, we spent a good deal of time talking about. So much so, our chats had been of such great help and comfort to me that I hoped that one day I would be able to repay her. I emerged from the room and helped her to bring the food from the kitchen.

"You have to be very careful. In Shanghai, the situation is so more complicated than any time before." I nodded.

She continued and said, "The influence and power of the International Settlement administration is controlled by the Japanese invaders and its puppet regime. Our lives are getting more difficult. Not only this, but the Shanghai gangsters have also split into three camps: one pro-Jap and the other two either pro-KMT or pro-Communists."

"I hate those traitors."

"You can't say this openly. 'Walls have ears.'"

I said, "I'll be cautious who I talk with and I won't disclose my feelings to anyone except you."

"After the Battle of Shanghai, the Japanese invaders had moved their troops to Nanking. The NRA had no power to stop them and Nanking was captured by the Jap invaders. Over 300,000 civilian and captured soldiers were killed. My relatives in Nanking were slaughtered by these Japanese bastards too. They aren't human; they are devils." Hearing this from her, the immensity of her loss left me feeling totally heart broken.

"Da Mom, (she asked me to call her this), I was an orphan, I think my parents were killed by them too. Many people like me come from broken families."

The striking of the hour of the wall-clock reminded me of other duties I had to attend to, and I said to her, "I am in a hurry. Let's talk some time later."

She nodded and opened the door for me, she said, "Be careful! Will you be back for dinner tonight?"

I replied, "No, I'll work all day long."

Chenghuang Temple is one of Shanghai's most famous. Built in 1647 and situated in the popular Huangpu, where people flocked to the temple to pray for wealth, health, safety, marriage and anything that was deemed necessary for a good life. In the Daoist religion, it is believed there are gods who specially manage the spiritual matters of the universe. 'Chenghuang' in Chinese means a governor in charge of a city. It is believed if someone could impress the spiritual governor of the city, all problems are solved. Chenghuang Temple therefore became the spiritual government of Shanghai.

I arrived at the Chenghuang Temple at half past six in the morning. There was the usual mixture of people in the temple worshipping and burning incense. I didn't have any idea where we would meet. The temple itself, was situated on a large plot of land of about fifty acres in area. I wandered along the main entrance hoping to see someone that would react to my presence.

A man holding an opened umbrella approached me and asked, "Do you know how to get to heaven?"

Such a strange type of question I thought, but there was something about the wording that was familiar. I tried to see his face under the umbrella.

He then went on saying, "Heaven has ways but you don't go; Hell has no door but you squeeze in."

Then it struck me! It was the voice of Old Dad, himself.

As he closed his umbrella, I managed to see his face and was unable to restrain myself from my emotions. He quickly got me to hush up though, and motioned me to follow him and he led me off somewhere. In front of an altar, we knelt down to pray like the other people, with their burning incense in hand to ensure that we weren't tailed. Under this cover he said, "Young man, we should be safe. You should know about the increasingly dire situation in Shanghai. The KMT intelligence station has been badly damaged after a united attack by the puppets and the Japanese.

There are two missions for you: First, you have to use whatever ways and means you can to assassinate one of the chiefs of the puppet regime. His name is Tong Shao Yi, and he is insidious, and highly vigilant. He is protected by well-trained bodyguards. Since no one is perfect, there must be a weak point we can use to take him out."

I asked, "Does he have a weak point?"

Just then we were interrupted by some women that came in. He winked to me as a signal to go. We left as if we were going to take a walk.

He continued and said, "He likes antiques. He is expert in appraising antiques."

"He lives in the Siccawe. You have to find your own way to assassinate him. The second mission is to detect two tons of missing gold."

"Two tons?"

"Yes, two tons, and not a tael-weight less! When the KMT was facing a losing battle in Shanghai, they planned to remove their valuable resources. Gold, of course, was the top priority."

He purposely looked into my eyes as if to emphasise the importance of what he was about to tell me, while saying, "It was the man who was the head

branch manager of the Bank of China, in Shanghai, organised the task of moving the gold reserve; the NRA was assigned to protect the removal of the gold."

The NRA deployed a special squad of ten fully-armed soldiers and two trucks to assist him in the removal of the gold. The one in charge of the special squad was Captain Wang Fu, and he was assisted by Sergeant Luk Feng. The gold and the special squad went missing; they simply disappeared!"

"Where did they go?" The thought of so much gold disappearing like this astonished me.

He went on to explain that the Japanese and their puppets got wind about this movement of gold and they set about chasing the gold too. However it seemed that gold didn't end up in their hands.

"What happened to the gold then? And where is the squad that was sent to guard it?"

Old Dad's answer surprised me as it was something least expected, "This is an important mission that Mr Dai Li (chief of KMT's intelligence) has nominated you to carry out."

"Mr Dai Li assigned me this mission?" My voice carried a tone of incredulity.

"Yes." His simple answer in the affirmative brought me quickly back to focusing on the task ahead.

To me, it was hardly believable that the intelligence chief would know me. Old Dad again felt forced to use a hand signal to stop me from raising any more questions. He showed me a photo of the captain and the sergeant. He said, "I know you have a Magnum pistol, but I'll give you one more with a silencer. I've left it in the tree pot near the engraved god behind the back door. After I leave, go there and look for it yourself. I've also left some money

and little gold bars there for you. If you need to see me at all, leave word in the same place, and be sure to leave it in code. If I receive anything, I will make arrangements to see you."

Then, almost as an afterthought, he added, "Hey, young lad, I almost forgot to tell you about one more important matter."

"Some more jobs for me?"

"These two jobs are more than enough for you to deal with. You have to kill Tong Shao Yi as quickly as possible; it has to be done within the month. For the second mission, you have more time to accomplish it. But hopefully you can get it sorted out within a month or two. Boss would encourage you by letting you keep some of the recovered gold for intelligent works. Aren't you happy?"

"Happy! What was the matter you almost forgot to tell me?"

His grimace quickly altered to betray a smile as he said, "Well now, this won't be forgotten! You have been promoted to the rank of lieutenant of the Bureau of Investigation and Statistics (BIS)."

"Lieutenant?"

"Yes, lieutenant."

"Unfortunately, I can't give you the appointment papers now. But I can assure you, they will be ready for you by the time you have completed these two missions … I have to leave now. If I don't hear anything from you, we'll meet back here in two weeks to see how you're getting on."

Just as he was leaving I called him back and asked, "Could you give me a photo of these two men suspected of taking the gold?"

"I'll only let you see them one more time, so take a good, long look at them to familiarise yourself with their features. You can't keep the photos as it

would be far too dangerous if they are found by the Japanese or the puppets. Remember as much as you can. But I must tell you, they won't look the same as in the photos. You'll have to use your own intuition to work out who they are when you finally meet them."

He shook hands with me and left quickly without looking back.

It was late in the evening and, as usual, I was waiting at the Paramount for customers. A man in formal dress commandeered me to take him to the Siccawe, a luxury residential area held under the French. He appeared to be drunk and almost immediately fell into a deep sleep accompanied by fits of voluminous snoring. About two more blocks from our destination, a car that had been following behind us, suddenly overtook my rickshaw. I didn't feel anything amiss with this and so pulled over my rickshaw to the side of the road to let it pass. However it didn't pass to roar off down the road, but stopped right in front of me. Then, when I tried to go around it, three men got out of the car and one, armed with an axe, charged at me waving the axe about in a blood-thirsty manner. Immediately I reacted by lowering my rickshaw and using it as a back-up defense. In the blink of an eye, and while still attached to the handle of the rickshaw, my foot flashed into action in the manner it had been trained, to send this attacker spirally backwards through the air for some five or six feet. The remaining two would-be attackers were left aghast, stuck in their tracks at the sight of this. Fortunately this gave me the precious time to swing my rickshaw around to quickly delve into the storage area beneath the seat to retrieve a wooden pole about two feet in length which I was able to arm myself with. My passenger in the rickshaw was woken by the melee taking place but I had been mindful to leave the rickshaw positioned so as to leave him with as little exposure as possible to what was going on.

Another one had picked up the axe by this time and proceeded to attack me with a changing-handed swing abruptly my attention and at the critical moment that he deemed as appropriate he brought the blade directly down

onto my skull, without taking account of the multiple ways training provides for evasive action in the face of such tired and conventional moves he was trying to make. By the time the axe had reached its proposed point of impact, I was already behind him landing several whacks on his ribcage with my pole. Immediately after the attack, I shifted to the front and faced against him. My attack sent him into a delirious state.He then started to take out his aggression on my passenger, and more importantly, on my rickshaw for he started swinging wildly, beginning with chopping at the back of the seat. By this stage he had lost sight of what he was doing and on seeing my passenger sitting there in such a vulnerable position, decided to raise the stakes by wielding the axe in full measure, down onto him. I span around to position myself as close as possible to the man with the axe. There wasn't enough room to use my pole against his axe, so I knelt down on my knees to twist my body back to shout "Hey!" at him. As he looked around, my foot, in a lightning-fast move connected with his elbow from below, sending the axe, spinning high in an arc, across the road. Just to make sure he got the point, I added a fist impression deep into his face which rendered it covered with blood, and him, a sorry sight, flopped down on the road with his face covered by the palms of his hands.

The third man, who as yet had not committed himself to any of the physical action, proceeded to scoop up and get his two compatriots back into the car so as to make some type of dignified escape.

All happened and was over within a few minutes, with the area being restored to its normal deathly-quiet ambiance. My passenger let go an audible wheezing sound then spoke to me, "Young man, don't take me home." I was replacing my pole beneath the paddle of my rickshaw when he said this.

I took in a breath and proceeded to ask, "Where would you like to go?"

"Let's get moving as fast as possible, as these bastards have just tried to ambush me, and you've actually saved my life."

He went on to give me directions of where he wanted me to take him. All the while I was left wondering what was going on as this surely wasn't intended as a surprise party. I figured the men who attacked us were some kind of Shanghai gangsters. And if so, my passenger must be a gangster too I guessed, and that would mean he would treat me as a comrade too, after what we'd just been through.

In any event, I didn't have much time to think about it. I arrived at the destination in Cité Bourgogne of Lokawei. It was a famous place for colourful characters to meet. I saw about five or six men wearing black coloured tank suits with individual flashes of colour added to adorn their characteristics. This was a dress code for ruffians in Shanghai. They greeted my passenger with the name, 'Uncle Four'.

"Uncle Four?" I looked at him while I racked my brain, for that name set alarm bells ringing as soon as I heard it. And then it came to me; this man they call 'Uncle Four' was in fact the infamous, 'Tiger of the Bund'.

"Oh, my god, I've got myself mixed up some of the biggest gangsters in Shanghai, and it's all happened by chance!" This thought now rolled around in my mind causing much confusion. I didn't even ask for his fare, but whether this was due to my forgetting to ask for it, or was it because I thought this man wouldn't pay me, I'm still not sure. In all probability, I didn't ask for it, expecting he wouldn't pay it if asked, in much the same way as those puppet suckers expect free transport. Instead, he beckoned me with a wave of his hand to stop me from leaving, and asked with a note of disbelief in his tone, "Little brother, why are you going away?"

"Your name causes me to fear, Sir."

He laughed and shared this with those about him in a good-natured way, "My name might make many people bust a gut, but not this young man."

His boys gave me a good looking over while he was saying this but they remained satisfied that I didn't pose any danger to them.

"Oh, yes, yes, Uncle Four!" They mumbled in agreement.

"You know what he did just half an hour ago? He fought with three bastards from the Axe Gang, one of whom was armed with an axe. Valiantly he fought them with bare hands and seriously injured two of the bastards, while the other snuck away like a rat. Why would a man like him be afraid of me?"

He tapped on my shoulder, "Come in, my man, I want to pay you a handsome amount for your fare. Do come in!"

I followed Uncle Four into a traditionally style of Shanghai house with a touch European flavour and colour. In the middle of the lounge room, there were two mahogany chairs with a big tea table between them, flanked on both sides by two pairs of table and chairs, enough to accommodate 10 people at a sitting. Chinese style is to have the head and important guests sitting in the middle. Others who accompany them sit on the flanks. Fengshui (geomantic studies), explains the left wing as 'dragon' and the right wing as 'white tiger'. The head embodies both 'dragon' and 'tiger' to form a spear-head fighting mode. When I came in, I saw one man sitting in the middle, a young lady and a young man standing on the left wing. Uncle Four invited me to sit by his side at the first table on the right wing. I humbly replied that I shouldn't sit by this side. I looked way out of place wearing my rickshaw jacket No. 454. Two people sitting on the left wing were looking at me through beady eyes. Uncle Four, by this time, practically ordered me to sit down beside him. We were served with tea from individual teapots. The man who sat in the middle of the hall, invited all present to drink tea. I sipped the tea while sitting upright in the chair.

The man began, "Brother Four, I have heard that you were attacked by our enemy today. Most probably it was the vicious Axe Gang, and most fortunately for you, this young man saved you. Is that right?"

Uncle Four replied, "Yes, Big Brother, I had drunk so much, I fell asleep.

They attacked without warning. If I had been conscious, I wouldn't have needed anyone to save me."

Big Brother now directed his words to me, "What is your name?"

"My name is Chen Sheng. Everyone calls me 'Sheng.'"

"Why made you fight the way you did to save my fourth brother?"

"I had no intention to save or offer him any other measure than that I would take to protect any of my customers from harm. The circumstances were that I was attacked by three of them, and an axe. My normal reaction in times like this is that I should fight; there wasn't any other alternative."

Big Brother asked, "You seem to have a good grip of Chinese marital arts. So what is your faction?"

"I study 'Tiger Crane Paired Form Fist.'"

"That's one of the famous Shaolin fist arts …What else have you studied?" He was obviously quite an expert in this field as well.

"I've studied Chinese cutlass arts as well."

"What is your favourite weapon?"

"As a rickshaw man, I don't need to fight. But most of the time after work, I practise with my Tow-rope Stick."

He asked, "Your Tow-rope Stick? That sounds funny. Can you show it to me?"

I pulled out my device which I always carried with me, and handed it to him with two hands, and a bow to show my respect. The stick in fact was a wooden handle, about 9 inches long, with a rope just over a yard long, attached at one end, and capped off with a knotted lanyard at the other end.

Big Brother examined it carefully and said, "This is not a weapon. It's just some rope and a stick. I think it is only good for tying luggage on a rickshaw."

"Sometimes, I used it for such purposes."

My response raised some laughter among those present, but not with the young girl who was standing there staring at me without a trace of a smile on her face.

"Father, can I see it?"

"Take it." He handed it over to his daughter. Holding it carelessly in her grip as she twisted around it to observe it fully, she ended by remarking in a caustic way with a dismissive tone, "Rubbish!" She threw it in a high arc into the middle of the hall. Although I didn't want to show it, this angered me greatly to see her treat it with such disrespect. Instead, quick as a flash I spun around to give the momentum I needed, then lunged into the centre of the hall to catch it before it came close to landing on the floor. I then held my two clenched fists together and bowed humbly to all who had witnessed her bad tempered outburst, inducing Big Brother to say, "Young man, just from the few movements I've observed you going through, I can tell you're very skillful in martial arts … Can you show some more skills to us?"

"'Beyond mountains there are mountains and beyond heavens there are heavens too.' I am nobody. Will you just let me go? Fare paid or not paid, that is no matter here that should concern me."

As I was about to turn around the young girl jumped up from the side of the hall and stood right in front of me and said, "You look you have a big temper! Your conceit for your possession of skillful martial arts riles me, especially as you don't want to share them with the likes of us, is that what you are saying? … You think you can come in and out of this house at your leisure, don't you? Well this is a 'Dragon Pool & Tiger Cave' you've strolled into this time. No one dares to walk in and out without permission."

Much to my relief, Big Brother intervened by saying, "Little girl, you can't be so impolite to him as the way you're acting now, for you've insulted him enormously by throwing his fighting stick away in the manner you did. Sit back."

She looked to her father for some measure of approval and finding no great support forthcoming from that quarter, she turned to face those in attendance and said, "All right, I may be wrong, but I don't believe this man has better marital art skills than I possess. I am willing to learn from him."

Annoyed with the developing situation, Uncle Four addressed the following to all, "He is my friend. It is my wish that everyone should give him good face." And then it began as swiftly as she had dispatched my Tow-rope Stick across the hall. Speaking directly to me, she said, "Would you like to contest a few rounds with me?"

"The men around here are men! I am only a rickshaw man. My involvement with the martial arts is for purely health reasons."

"Nonsense!"

She obviously didn't have another word to say on the matter, and instead moved in closer on me. Raising her hands, she swirled them like a butterfly in flight.

"You practise Butterfly Hands?"

"So what?" she continued to challenge me with her aggressive tone.

"I have learned some of the skills and movements of the Butterfly Hands style. If you can touch my rickshaw jacket, you are the winner."

"I don't need any concession from you," she spat out. "You make your attack with full vigour."

This set her to revolving her hands in a palm-shape as she tried to cut me up like a vegetable chopper. Aware of her strategy, I was mindful to counteract her attack. I shifted my shoulders deftly from left to right, and when the next palm came down, I slew my shoulder from right to left thus deflecting all her power with a gliding palm without her making any actual contact with me save for the rush of air that took place between us. Lowering my body while spidering my legs, instantaneously I was able to stand up and counter with one of my palms hitting her shoulder which sent her in a percussive backward movement, away from me about 3 or 4 steps. Realising the nature of the challenge she faced, she altered her position by raising one leg while the other leg was left rooted to the floor. This was partly ploy, partly a crack of indecision, as the use of the leg movement was set to distract my attention. I knew her tricks and this insight gave me a clear line for my strategic defense capability. Her next line of attack would possibly come from the stagnant leg on the ground position but, cunningly she shifted her line in anticipation that I had already picked up on her subtle intentions.

In confronting me, through the ebb and flow of our movements, I guessed it afterwards, she had detected I practised in the art of the Butterfly Hands movements. The position she made was termed the 'Golden Chicken Standing Still'. She made a circle turning on the one leg; as soon as the turn was completed, her leg suddenly folded under to use the force to roll over to clasp, crab-like, the lower part of my body and compress my legs and waist, twisting me down in a slow spiral to the floor. Before she could reach my legs however, I flipped two backward somersaults causing her a mid-flight strategic change of plan, which her intuition processed as a forward flip to catch me. Having no place to move, I brought one palm up to protect my chest and the other one held outstretched to repel her. This action effectively countered her attacks and stymied her game plan.

I held two fists together and said, "That's enough for today."

Her father laughed loudly and said through his guffaws, "Xiao Ya, this young lad has got you well and truly out-manoeuvred; his right hand is set to attack your head and his fingers of the other hand are stretched out to gouge out your eyes, leaving you a blind butterfly."

Her father's comment however had fallen on deaf ears as she flared up with her dressing down despite her father's frown, moved directly to the weapon stand and selected a long spear and mouthed to me in articulate sounds, "Hey, you come again, this time holding no mercy for me. Go as harshly as you can! Take out your rubbish rope stick. I want to see how fierce you are behind it!"

On hearing the word 'rubbish', it cut through me like a thousand arrows piercing my heart, for the rope that it was bound with, was a sinew to my heart, the rope that binds Wendy and me. I took it in hand and began staring at her. Judging by appearance, she was about eighteen years old, with an almond coloured face, cherry lips, white teeth, watery dark eyes, and with the tips of her eyebrows curving upwards like a phoenix, she presented a formidable sight.

Added to this was her lavish dress-sense, for she was dressed in an embroidered silk suit and very fine supple shoes, she was the picture of feminine allure, but like a leopard that struts and frets its stuff, a very pretty girl indeed, in attack mode, however, she'd strike you to death.

Rotating the long spear on its axis, like a drill in the air, she slowly and precisely took aim at my chest. As swift as a swallow, I moved my body just in time as it darted right past me, closely missing its mark. With precise intervention, my Tow-rope Stick was already in counter flight to bring down the spear. The moment it made contact, the rope automatically bound tightly around the middle of the spear, suspending its projection and withdrawing it from service to my worthwhile hands. I grabbed it immediately and put it on the ground and said, "Please accept my apology for this offence to you, but we're far better off without it, for the damage it can do!"

Her face turned red leaving her to walk back to her father's side, where she remained in silence for some momentary relief. Then suddenly I felt it, she slanted her eyes and glanced curiously at me until my field of vision connected with hers which she quickly relinquished as shyness overcame her, turning her head back to lean on her father's shoulder. Her father clapped his hands and everyone in the courtyard began clapping hands too which brought things back down to a more acceptable level of ambience refreshing the hall after the fire and brimstone just witnessed.

He began to say, "Now, I believe you are well-practised in the field of martial arts and that's why you were able to defeat the Axe Gang's attack on my man, with their axes."

"Let's go sit down and talk about it."

He invited me to sit next to him.

I said, "I'm not worthy of that. May I sit back in the same place again?"

He turned to Uncle Four, "Brother Four, what should we do with him?"

Uncle Four said, "I want to admit him as my pupil."

At this, Big Brother turned his head to me.

I said, "I am but an orphan of no consequential means. Your plan for me is most considerate and kind, but I am used to living freely without any restrictions to tie me down. I want to stay as a rickshaw man, a person with no worries or cares."

Uncle Four said, "Today, you offended the Axe Gang, no, not offended, something much worse than that, and soon they will be actively out there digging you out to carry out a vendetta on you."

"I am nobody, they wouldn't bother with trying to take out revenge on someone as insignificant as me; I am merely an ant, in this giant

nest of Shanghai. If they did, and word got out about such petty minded vindictiveness, they would be the laughing stock of The Bund."

At this point I walked to the centre of the hall to enforce my leave by saying, "Thank you for your warm hospitality here. I must get back to my duties for at this particular time, the rush is on, and it's the staple of my work."

Uncle Four said, "Good! Understood! Young lad, you have guts, let us be your brothers. Whenever you have a problem, no matter where in Shanghai, just come to us. I'll render my utmost effort to help you."

He then drew from his pocket a handful of money and attempted to plonk it in my hands.

I brushed his hand aside and said, "I can't take that much, I only need to be paid for the fare." He pulled a long face and said, "You must take it all; otherwise I won't treat you as my brother."

I did nothing but saying, "I accept your kind offer rather than that of over courtesy. Thank you so much!"

Big Brother, stood up and said, "Today, I am so happy for the chance to meet this young man, for not only is he imbibed with good martial arts, his breeding and outlook are of the highest standard of integrity. Let's share a refreshment before he departs."

A servant arrived bringing goblets and wine which he handed around to those close by. When all were served their portions, Big Brother led by raising the fellowship to a warm-hearted glow, "Let's toast our new friend, Sheng, bottoms up!"

After I drank my fill and was set with the intention to leave, Xiao Ya holding her goblet of half-finished wine, came up to me and said in a demure voice, "Brother, please forgive my impatience and ignorance for I still have much to learn. I have offended you deeply, it's not hard to see, now I look back

on it. I can hardly believe the full frontal attack I made on you. I have no idea of what came over me! This goblet of wine which I readily share with you, represents my deepest apology."

As she passed it to me, "Thank you, my pleasure," I curiously replied.

The servant came to refill our goblets with wine. I held the goblet delicately as I took a little sip in a communion of sorts, for though at the time I had no idea of the consequence, the rush that I experienced was from being stunned by her appearance and the manner.

She sipped the wine slowly with the sight of me reflected in her watery eyes. I felt as if an iced circle had been sawn open to reveal a new pool of life.

'My soul is flying to the heaven!' I mused.

Hearing this, I emptied the wine in one fitful gulp as I gathered myself to recover from what I just felt, and then cavalierly attempted to make my escape. "It's been such a great and unexpected pleasure to meet you."

Determinedly now, with my fists clenched together, I paid respects to Big Brother, Uncle Four, Xiao Ya and everyone in the hall and said, "See You!". They saw me off from the front of the house, where I left them standing and waving as I drew off into the distance.

The Kidnapping

After changing into casual wear suitable for riding a bicycle, I arrived at Wendy's home at six o'clock and found her waiting for me at her gate. She was wearing a grey tracksuit, a scarf and a bonnet on her head. I waved to say hello and said, "You're looking very pretty tonight."

She smiled without saying anything. After a while, I rode my bicycle closer to her and said, "I won't ride all the way with you to your school and I'll keep a distance between you and me."

She asked, "Why?"

"I don't want your colleagues to know I'm here keeping an eye on you. It's best if they have no idea of what's going on."

"You're probably right. Sounds like the best way to handle it."

"Hey, you've got a great bike there; it's got gears and a double chainwheel."

"I like cycling, that's why my dad bought me such a good bike with multiple gears. I can pedal up steep hills in low gear, and really fly down them in high gear."

"Mine's just a simple bike with no gears. It's got no brakes either. It's a fixed-wheel. I have to use my legs to backpedal to slow down. You should be able to ride much faster than me."

"Well I'm not sure about that … you're much stronger than me."

"You'd better get going to meet your colleagues now. Don't keep them waiting. How long would your meeting take?"

"It should be finished in about an hour."

"I'll take a look around the area to check things out. If you see me with a scarf pulled up around my face, just ignore me. That'll mean something is going on. The best thing to do if that happens is to go straight home. I'll follow you at a safe distance to make sure everything is alright."

She made it clear that she knew what to do. She then rode on the bike towards the school. When we arrived, I kept an eye on her and saw her riding inside the school. I looked around the area and saw Siang hiding behind a post box. From there he had a good vantage point to survey all the comings and goings around the school. He beckoned me to come closer so he could let me know what he'd seen. I asked, "Siang, have you come across anything that's caught your eye, or anything we should be on the lookout for?"

"It's all surprisingly calm, actually," he commented. "Let's take time out for a drink at the café over by the front of the school."

After entering the café, we sat by the window with our drinks so we could see people going into and out of the school.

Inside the school Wendy began her addressed …

I went in to address the C'SOS people. There were twelve of them sitting there waiting for me. I apologised for being late and when everyone was settled, I began, "What we are dealing with is not just the imminent threat to our safety and security throughout Shanghai, it's in the Settlement that we're going to see profound changes that will affect us very seriously. The Japanese are on the verge of declaring war with the Brits and Americans, and other allied powers that support them. When this happens, the Japs will invade the International Settlement first up, and journalists will be one of the key targets. They'll be after us so they can stop word getting out to the West about how their military forces are ruthlessly killing and controlling Chinese people.

We have to work out the best forms of action to take to counteract this

new level of threat we face. I would highly suggest starting by restructuring our organisation. That way we'll have a fighting chance in defending ourselves against them. We need to re-shape the organisation into one based on vertical integration and communication. John, Judy and I are at the top of the hierarchy, and the rest of you will be split up into five teams, with two members in each team. Direction needs to be funneled by us through the different individuals manning each of the other levels. Doing it this way, no one has access to all the key information in case someone is captured by the Japs. That provides us with operational integrity, as, even if any of us are captured and tortured to extract information, they won't be able to get whole chunks of our vital logistical information which they could use to wipe us out with."

At this point, a new member to the group, a fellow by the name of Jing, raised his hand and asked, "The existing structure is simple and efficient. Why mess with it by making changes? If it works fine at the moment, leave it be."

I stared and remarked to him in a clear no-nonsense way, "Our system is going to be soon put under a great deal of pressure by the Japs. Although the Settlement Municipal Police aren't perfect, the law has still operated fairly well, in general terms, across the board. However, with the strict new system the Japs will impose on us, as they stamp their mark of authority, they will be highly vigilant in clamping down on any form of dissention the moment they suspect it. There's nothing surer than that; just as they did in Nanking, they'll come down hard and regulate the freedom of our people to a state of servitude under pain of death. You can be certain the Japs won't be kind to us. A lot of the Green Gang have already cleared out of the International Settlement, and stacks of foreigners and expats have closed down their businesses, and headed back to their own countries. If we don't change our system, we'll be stuck and end up in big trouble."

Jing raised his hand again and asked, "Can we postpone doing it now, and implement it at a later stage?"

I dismissed him pretty quickly for raising such a ridiculous question, by saying forthrightly, "The decision has, in effect, been made and we're not going to change it now. John's organising a separate meeting in the next room. He'll brief each of you, in turn; and remember, all of this is highly confidential."

"John, please take our colleagues to the next room for briefing."

He replied, "Yes, I'll brief each of them, one after the other, on the new system. Don't worry about that."

Speaking with Judy about our funding after they had left for the other room, I said, "As you're in-charge of controlling the finances for our project, keep an eye on the different accounts because I'll deposit money or gold in different ones for you to access. John and you are the only ones that are authorised to draw on this money. Don't mention a word of this to any of the other members. You can leave now, I'll contact you by posting a notice on the board in the student union. Pay attention to the 'Music Concert' listings. Here's the code handbook you'll need for unscrambling the messages."

Judy said, "You're really being so cautious about all of this. Is the situation in the International Settlement as bad as you make out?"

"Yes, it's even worse than I've made out so far! A good friend of mine who works high up in the government, warned me about it. We simply have to take it seriously. You'd better leave now without saying goodbye to them."

I could see her eyes full of anxiety. I gave her a hug and a kiss on her cheek, while saying, "Don't worry, we'll overcome all of this misery and anguish eventually! Deus te beneicat."

"Deo gratias." Then she disappeared.

Outside the school, Siang kept a firm eye on the gate to keep track of those coming and going. No one escaped his gaze. He noted a girl who left and about ten minutes later a male walked out. A spark of recognition flashed

in him when this happened and he called me over to see if I recognised the person. Both of us had a feeling we had run into him before but neither of us could put a finger on when, or where.

I slipped off after this to quickly visit the toilet while we were waiting on Wendy to come out of the school. When I got back to Siang, and Wendy still hadn't shown up, Siang alerted me to something suspicious going on in the street between a man standing beside a car who was checking out the street with the driver. They were searching for someone or something as they were obviously working in collusion, pointing and peering over the streetscape. They both looked like undercover agents.

I kept my eyes on the saloon car, and said to Siang, "Siang, put your scarf over your mouth. That's the sign for Wendy not to come near us. When she arrives she'll know straight away to head home as something's on the go. I'll follow her at a safe distance on my bike, and you do the same and follow me."

"I haven't got a bike."

"Look, there's some over there near the post box. Go and pinch one!"

"Quick, be quick!"

Just then, Wendy rode out onto the street. She saw the scarf covering my mouth and knew something was happening, and started to immediately ride home. I couldn't work out why she was riding so slowly in the direction of the Bund, but then I saw the car trailing her bike. She arrived at a junction between Route des Soeurs and Ratard Rue, and quickly turned her bike around and took off in the opposite direction. The car could not possibly keep up with her. She scattered pedestrians on the street as she mounted the footpath and rode between stalls, rubbish bins and all sorts of obstacles. People were jumping out of her way and yelling out loudly as she tore off down a dirt track leaving them all for dead. The car didn't have a hope in the world of keeping up with her. She quite easily managed to break free of everyone.

Suddenly two men jumped out of the car and dragged bicycles from passing riders by tipping them on their heads. They raced off after Wendy and started to catch up to her as she was zipping down a steep hill. There were now five bicycles in the chase. Siang was running last, but still within eyesight. I glanced and saw the man behind me drawing his pistol and pointing it at me, but I ducked and wove giving him little chance of hitting me. Siang soon caught up with us, after the man stopped in the middle of the path and held out the pistol like he was going to start shooting at us.

I shouted, "Siang, take this bastard out … I'm going ahead to protect Wendy." Without blinking, Siang crashed into his bike, sending the rider and bike both flying through the air. I swerved back and rode over his hand holding the pistol. With him screaming like a baby, Siang wrenched the pistol out of his hand and pointed it at him. I murmured, "Thanks Siang."

Siang smiled!

The other man knew I was on his tail, but he was more intent on chasing Wendy. Meanwhile Wendy was riding like a moto-cross champion taking full advantage of the benefit and speed the downhill incline provided her with. She goaded one of her pursuers who thought he had her number by letting him get close enough before speeding off which caused him to go into a skid on the pebbles and land flat on his face. But this didn't stop him, he picked up the bike and went after her again. I wasn't much help as I was too far away. Wendy continued to goad the man. When she came into a right-angle corner, she didn't brake to slow down, but instead, lowered her head and shoulders to sweep through the bend on a wing and a prayer. Not so lucky was her pursuer. He failed to assess the corner and ended up crashing head on into a wall. He dropped down on the road. When I arrived, he was trying to stagger back onto his feet. I got off my bike and charged at him as he tried to pull out his pistol. I let fly with a kick to his arm which shuddered through his body. His face swelled up in pain as his eyes filled with tears and he begged me to release him. With his pistol now in my hands, I forced him to stand against the wall

to frisk him. I turned out his pockets but only found a wallet with little money in it. I pressed his head heavily against the wall and asked, "Who are you? Why did you follow the girl? Are you a police, or a Jap spy?"

"Big uncle, don't press my head too hard or it will break like an egg. I beg you."

From his response, I guessed he wasn't a spy or police. But I kept the pressure on him by pressing his chest with my elbow.

"Big uncle, I'm only a hooligan who earns his living for a bite to eat."

"Bullshit! You've got a pistol and you wanted to kill me."

"The gun is a fake. Check it out yourself. I only use it to threaten people."

I checked it, and sure enough it was just a replica pistol. I couldn't help raising a smile on my face at the irony of it. As I continued to grill this kidnapper over his reasons for pursuing Wendy, Siang caught up to me on his bike. I called to him, "What's happened to the other bastard?"

"I fixed him well and truly."

"Did you kill him?"

"Nope, but I busted his leg."

"Why didn't you finish him off?"

"He begged me not to kill him. He said he was just a hooligan and that someone had paid him to kidnap Wendy."

"Did you ask him who wanted to kidnap Wendy?"

"He said he didn't know and showed me the money he got paid to do this. I took his money." He then drew the money from his pocket and handed it over to me.

"Tell me who wants to kidnap Wendy or I break your neck."

"No, please don't. I swear to you I haven't done anything to hurt your girlfriend."

By now, those who had been chasing her had been brought to book; Wendy came riding back towards me. She stopped besides me and said, "Thanks, Sheng and your brother, you saved my life."

"Do you know him?" I asked Wendy.

"No, I don't."

"He told us he's been paid by someone to kidnap you."

"Kidnap me, whatever for?"

"Maybe, since your father is rich and they figure they can get a big ransom from him. You know Shanghai is very complicated and anything could happen here." I continued, "What would you like me to do with him?"

With his eyes full of tears he stammered, "Big sister, don't kill me. My mother is old and I have wife and two children. If I die, they'll starve to death." He knelt down and kowtowed to Wendy.

Wendy responded, "I don't want to see you killed. But you must guarantee that you'll not do anything bad again."

He said, "I swear to you I won't do anything bad again."

Wendy said to me, "Let him go. He is a poor man."

I kicked him and said, "You're lucky today. She has Buddha's heart and doesn't want to hurt anyone." I kicked him again and said, "Go, take the other bastard with you and clear off. And be sure to tell him if I catch either of you in my sight again, I won't give any warning, I'll just treat you lower than a dog."

He walked backwards, bowing to Wendy and I, then turned and ran off as fast as he could.

After giving it some thought to avoid anyone else following her during her work hours, I turned to Siang and said, "Please escort Wendy from her home to the office and back, this week."

"Yes, sir!"

I gave him a pat on the back and said, "You don't have to call me 'sir', we're brothers."

"If there's nothing else to do now, I'll take my leave."

"Thank you very much, you've been a great help. Let's meet at the restaurant for lunch tomorrow."

"Okay, see you tomorrow. Bye bye!"

On our way back, while riding beside Wendy, I asked, "Have you received any blackmail letters or anything of a threatening nature that scared you?"

"No, I haven't … Oh, yes, now you mention it."

"What was it?"

"About a week ago around lunch time, there were a few men standing outside our news agency. When I came out to go for lunch, they were staring at me and then started to follow me as I walked to the café. I walked for a moment or two and then went back to the office. I asked our security to keep an eye on them. When they saw the security people checking on them, they separated and moved off in different directions."

"Did they come again?"

"Yes, they did, and there were two new faces with them this time."

"I guessed the new faces might be these two bastards."

"Yes, I remembered, you're right."

"What did you do?"

"I called security to check them and, like last time, they took off in different directions."

"Don't worry, Siang will be there to protect you. You are going to work, aren't you?"

"Of course. These people don't scare me."

"How about your father? Has he any plans to leave Shanghai and take you with him?"

"No, he hasn't, as far as I know."

"Is that because he is too well-connected with the Japs and the puppet regime?"

"What do you mean? Do you really think my father is a traitor to our country?"

"No, I didn't mean that. What I'm worrying about is the Japs' invasion of the International Settlement, and just how unsafe that will make life for you."

"No one is safe in wartime. Although I am not a soldier, I am prepared to die for my country, in the same way as you, as a soldier."

I looked at her and could hardly hold my emotions in check with the strength of conviction and loyalty she conveyed with those few words. In reality, I should have set emotion aside and tried to rationalise the situation logically. "If you want to stay in the Settlement irrespective of what happens, you shouldn't stay with your parents."

She looked at me with eyes wide open.

I shouted to her, "Be careful! Let's pull over and talk about this subject seriously."

She nodded and slowed down to a halt.

"Are you hungry?"

"Yes. I am a little bit."

"Around the corner is a noodle stall that I used to visit frequently when I was a rickshaw man. I like their noodles and the soup they serve. It tastes just like the food my mother used to make." Wendy sensed the depth of feeling I held in my heart for my mother. As we dismounted from our bikes she reached out and hugged me, which took me by great surprise. Then she planted a tiny kiss on my left cheek again, something entirely unexpected, and said, "Don't wallow in the past; that will only hurt you, my dear."

I nodded and said, "Don't worry, I'm fine. Let's leave our bikes here."

The noodle stand operator was happy to see me after such a long time. He gave the table a good cleaning with his towel and said, "Haven't seen you for ages. Welcome back!"

He continued, "Would you like your favourite noodle soup?" He kept his eyes on Wendy and wondered how to greet or ask her.

I said, "This is my girlfriend. She'll have the same as me, but give her a smaller portion."

"Sure, I can do that."

"I hope you like the food."

"I like everything you like with the exception of one thing."

"What's that exception?"

"I can't extend my felicitous feelings to your paramours."

"Oh, my God!" My mouth opened, but it remained speechless beyond those three words. "Oh, my God!"

"Don't worry, so long as you don't betray me, I can live with it."

"No, no, I only love you. No one else."

The hawker brought two noodle soups and placed them on the table. He appeared to be embarrassed by what he had walked into and heard Wendy and I talking about. After bringing us the food he left quickly and didn't look in our direction again.

Wendy continued with a smile, "Don't speak about it too loudly in the open. It embarrasses people. I want to see you work it out yourself." She continued, "For now, let's skip this subject and talk about our plans for the future."

"You'll have to move out from your family and live alone."

"Why?'

"Now, you're involved in a secret organisation that is set to challenge the power of the Japs. If anything goes wrong, if the shit should hit the fan, your parents are going to be the first ones to be affected, big time."

I paused at this point to see how she was reacting to the seriousness of the situation she would soon find herself in if she continued to blithely go down the path thinking her group had some type of moral imperative that would protect them from harm's way. I watched her as thoughts about her new predicament churned over in her mind. In the end, she seemed to agree with my advice to live away from her parents.

"Where should I live?"

"You'd be better off living in the Chapei."

"You mean I should get out of the International Settlement?"

"If the Japs invade the International Settlement, there won't be any difference where you live as they'll treat everyone, irrespective of where they live or where they come from, as badly as they deem fit. According to their normal form, they ruthlessly tighten control of newly acquired areas to show their powers, so they'll throw their weight about when they take control of that prized possession, you can be sure of that. But with the Chapei, they have occupied it for almost four years. Most of the administrative functions have been handed over to the puppet regime. Once it becomes their responsibility, life becomes a lot less repressive mostly due to the bumbling way the puppet government carries out their duties in such an inefficient manner."

"How about you? What are you going to do then?"

"I'll move away from here soon … I'm going to rent a condominium in Chapei."

"You mean you won't stay in that luxurious house that the Green Gang have set you up in? That'll be a bit of a come down for you!"

"You always try to embarrass me over that."

"No, sorry, I didn't mean to do that. It was just a slip of the tongue."

"I can find you a flat in the same area if you'd like me to."

"Is it an expensive area?"

"It depends on how big a place you want?"

"A small studio flat is fine for me."

"I'll let you go home and you can talk to your father about it."

"Would you like to come to my home tomorrow afternoon as I have the day off?"

We left the food stall and rode back to her home. I got off my bike as a courtesy to say goodbye. Much to my surprise, she hugged me and kissed me, on my lips. I held her tight and whispered, "I love you." She pushed me away from her and said, "It's getting late in the night. You'd better go home now." Reluctantly, I mounted my bike and rode off.

1937 戰火忘情
1937 The Lost World's Love

編劇／ 作曲／ 作詞／ 小説作家：陳見宏
Screenwriter/Composer/Author/Novel Author: Simon Chan

設計／ Design: 4res
出版：紅出版（青森文化）
地址：香港灣仔道 133 號卓凌中心 11 樓
Publisher: Red Publish (Green Forest)
Address: 11/F Times Media Centre, 133 Wanchai Road, Wan Chai, Hong Kong
電話／ Tel: (852) 2540-7517
電郵／ Email: editor@red- publish.com
網址／ website：http://www.red-publish.com

香港總經銷：香港聯合書刊物流有限公司
Hong Kong Agent: Sup Publishing Logistics (HK) Ltd.

台灣總經銷：貿騰發賣股份有限公司
地址：新北市中和區中正路 880 號 14 樓
Taiwan Agent: Modern Professional Distribution Co., Ltd.
Address: 14F, No 880 Zhongzheng Rd, Zhonghe Dist, New Taipei City 23586, Taiwan
電話／ Tel: +886-2-82275988
網址／ website：http://www.namode.com

出版日期：2017 年 6 月
Publishing Date: June 2017
圖書分類：歷史／ 戲劇
Category: History / Drama
國際標準書號 (ISBN)：978-988-8437-63-4
定價：港幣 80 元正／ 台幣 320 元正
Price: HK$80.00 / TWD320.00